VIVA GUADA LUPE!

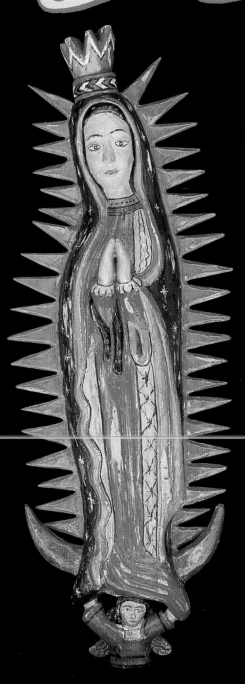

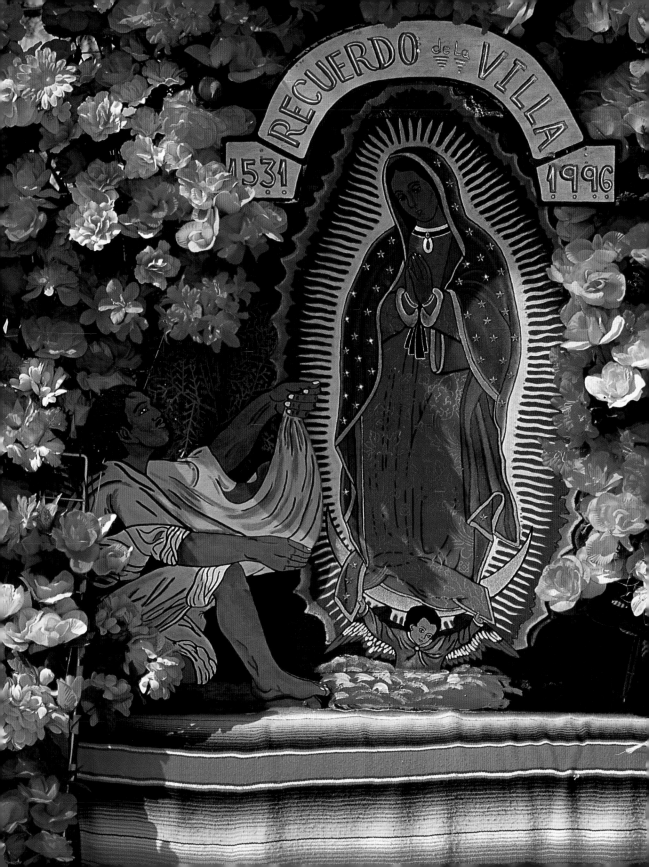

VIVA GUADALUPE!

The Virgin in New Mexican Popular Art

BY JACQUELINE ORSINI
DUNNINGTON

PHOTOGRAPHS BY
CHARLES MANN

Museum of New Mexico Press

Santa Fe

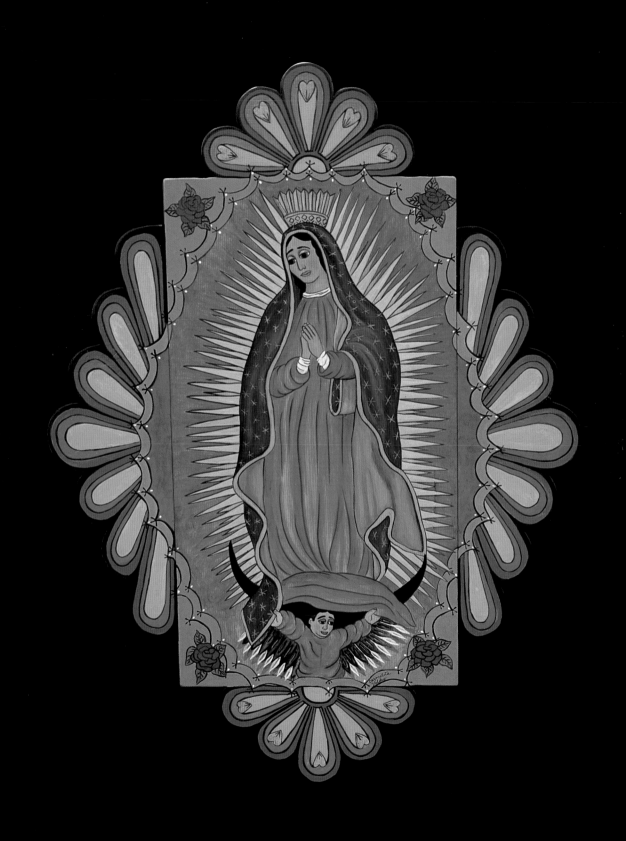

FOR MORE THAN THREE HUNDRED YEARS, the Virgin Mary of Guadalupe in her Mexican advocation has been celebrated in New Mexico. Devotees invite her into their lives with the cry, *Viva Guadalupe!* Far more than a religious symbol, Guadalupe is a folk symbol, an emblem of statewide culture and history. Although she has never been credited by the Vatican with an accepted appearance in New Mexico, she is very present with her followers and never absent from their devotions and celebrations in her name.

Guadalupe answers to many names—Our Lady of Guadalupe, la Morena, la Morenita, the Brown Virgin, la Virgencita, la Madrecita, the Dark Virgin, la Virgen de Tepeyac, la Criolla, and universally as Nuestra Señora or la Virgen de Guadalupe. Her faithful followers have elevated her to the position of Queen of the Americas. In a local vein, the Virgin of Tepeyac is known as

Carmelita Laura Valdés, a contemporary santera, offers her intepretation of Guadalupe at Spanish Market in Santa Fe (1996). Her colorful retablo reflects the unique spirit found in New Mexican sacred art—tradition and devotion comingled with a daring use of color and innovative design.

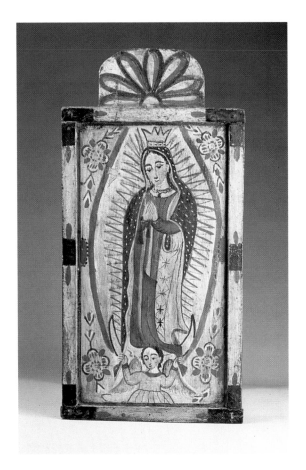

José Raphael Aragón (ca.1796-1862) was a major santero in northern New Mexico. His artistic style was marked by elongated, well-modulated facial expressions in his bultos, retablos, and altar screens. (MOIFA)

Protectress of New Mexico, the Madonna of the Barrios, la Pastora, or simply Guadalupe. She stands on home altars, lends her name to men and women alike, and finds herself at rest under their skin in tattoos. Guadalupe's image proliferates on candles, decals, tiles, murals, and old and new sacred art. Churches and religious orders carry her name, as do place names and streets. Trivial and secular items abound. Far from vulgarizing her image, these items personalize her and maintain her presence in daily life.

In all this diversity she is singularly the guardian Mother to her devotees, for Guadalupe stays with them throughout their lives and

walks with them over rough terrain on pilgrimages. At the end of this life, in reproductions of her likeness, she stands guard above their graves. Patroness of Mexican and Indian peoples, she is prayed to in times of sickness and war and for protection against all evils.

The popular Guadalupe story harkens back to December 1531 in Mexico–Tenochtitlán (Mexico City) when the Virgin Mary appeared four times to the Christianized Aztec Juan Diego. The Indian peasant was on his way to mass when, the narrative relates, a beautiful woman surrounded by a body halo appeared to him with the music of songbirds in the background. As the birds became quiet, Mary is reported to have announced, "I am the Entirely and Ever Virgin, Saint Mary." Assuring Juan Diego that she was his "Compassionate Mother" and that she had come out of her willingness to love and protect "all folk of every kind" (all recorded dialogue from *Nican Mopohua*, trans. by Fr. Martinus Cawley), she requested

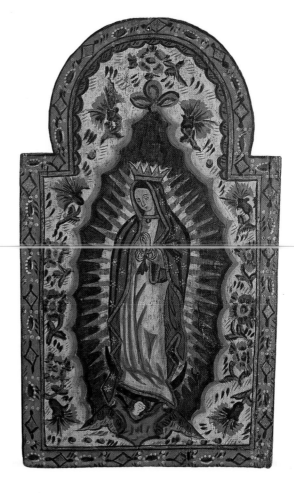

This delicate retablo of Guadalupe follows closely the Mexican tradition but with the inclusion of highly personal abstract and decorative motifs. School of the Laguna Santero (late 18th–early 19th century). SCAS/Photo: Jack Parsons

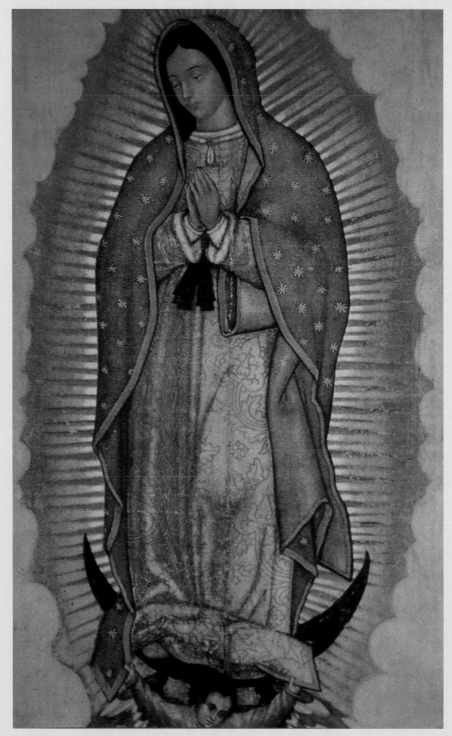

The "Miraculous Portrait" hangs in the new Basilica de Guadalupe in Mexico City.

that he build a temple in her honor at the place where she stood, Tepeyac Hill, on the eastern edge of Mexico City. The spot has been identified as the site where once stood a temple to the Aztecan goddess Tonantzin.

Juan Diego went directly to the bishop-elect of Mexico, Zumárraga, to relate this wondrous event. The churchman was skeptical and dismissed the humble peasant, who then returned to Tepeyac Hill and beseeched the Virgin Mary to find a more prominent person who was less "pitiably poor" than he to do her bidding. Rejecting his protestations, the Virgin urged him to return to the bishop-elect and "indeed say to him once more how it is I Myself, the Ever Virgin Saint Mary, Mother of God, who am commissioning you."

Juan Diego returned to the churchman's palace after mass, waited, and finally was able to enter his second plea on behalf of the Virgin. This time, Zumárraga asked the humble native to request a sure sign directly from the "Heavenly Woman" as to her true identity. The bishop-elect had some members of his staff follow Juan Diego to check on where he went and whom he saw.

The next day, Juan Diego hastened to the bedside of his dying uncle, Juan Bernadino. The old man, stricken with a pestilence, begged his nephew to fetch a priest for the last rites of the church. The following morning, before dawn, Juan Diego set off on this mission. He tried to avoid the Virgin because of his uncle's worsening condition, but she intercepted him and asked "Wither are you going?" He confessed that it was on behalf of his gravely ill uncle that he was rushing to summon a priest. During this third meeting, she assured him that the uncle was "healed up," as she had already made a separate appearance to him. This visitation would start a tradition of therapeutic miracles associated with Our

*The Castilian garden flowers associated with Guadalupe's final
apparition to Juan Diego are often depicted as the cabbage rose.
(Photo: JOD)*

Lady of Guadalupe. She also comforted Juan Diego with the
assurance that she would give him a sure proof of her real identity.

On December 12, 1531, the final phase of Juan Diego's contact with
the Virgin was initiated when she appeared
and bade him go to the top of Tepeyac Hill and pick "Castilian
garden flowers" from the normally barren summit. (Artists usually
render these flowers as the cabbage rose and not the five-petal,
bicolor Castilian rose, *Rosa foetida*, most probably indicated in the
folk narrative.) She helped him by "taking them up in her own
hands" and folded them into his cloak woven of maguey plant
fibers, the now-famous *tilma*. Juan Diego then set off for
Zumárraga's palace with this sure sign of the Virgin Mary of
Guadalupe's identity. As he unwrapped his tilma, the flowers
tumbled at the churchman's feet, and "suddenly, upon that Tilma,
there flashed a Portrait, where sallied into view a Sacred Image of
that Ever Virgin Holy Mary, Mother of God."

This imprint of the Virgin Mary of Guadalupe, the "Miraculous Portrait" as it is often called, hangs today in the Basilica of Guadalupe in Mexico City. The core image—the face, hands, mantle, and underdress—remains of inexplicable origin. There are no brushstrokes on these basic elements of the cactus-fiber tilma, and the original pigments still defy analysis. To the central image additions were evidently made that persist in the renderings of the present. Recent studies, using infrared radiation, reveal that the black-and-gold details, the angel, body halo, half-moon, and crown were obviously human additions, probably of the mid- to late sixteenth century.

Most scholars of art history view the added elements as direct applications of conventions from European religious art of the period. By the late 1400s, images featuring Mary as Virgin of the Apocalypse (King James Version: Revelation 12:1) were available in Europe and eventually through the Conquest in Mexico. The Scripture reads, "And there appeared a great wonder in heaven, a woman clothed with the sun, and the moon under

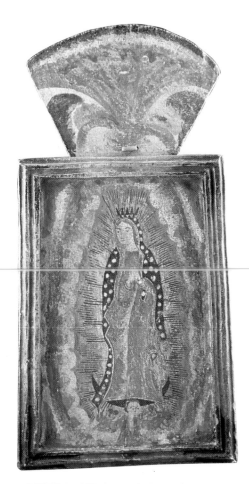

School of the Anonymous Santero "A.J." This artist, known only by his initials and one dated work of 1822, created this retablo of Our Lady of Guadalupe from a palette of bright colors. (MOIFA)

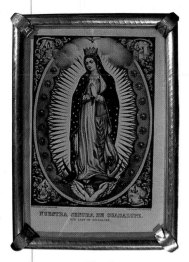

The famous printmaking partnership of Currier & Ives anglicized Guadalupe to suit the somewhat Victorian view of women in the late nineteenth century. (MMA)

her feet, and upon her head a crown of twelve stars." Other interpretations prefer a Mesoamerican origin for these mysterious symbols. Both sides agree that they are additions. An interesting detail is that many contemporary depictions of Guadalupe show her with a crown; the golden attribute was painted on her head in the 1560s and removed in the 1880s. With or without her regal symbol, the Virgin Mary of Guadalupe remains the popular Queen of the Americas.

Another Virgin Mary of Guadalupe, a statue, is sheltered in a remote monastery in Cáceres, set in northwestern Spain in the Extremadura region. The monastery has been a pilgrimage site since it was built in the late 1300s. In spite of obvious differences in appearance, there are strong links between the two Guadalupes. The most telling connection is their shared name. The name "Guadalupe" was brought to the New World by the conquistadores. Cortés was born within the sound of the monastery's bells. Professional linguists contend that the name Guadalupe is clearly from the

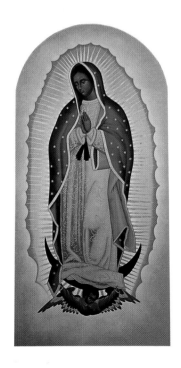

A contemporary depiction of Guadalupe in a classic style graces the center of the main altar screen in St. Francis Cathedral in Santa Fe. (Photo: ET)

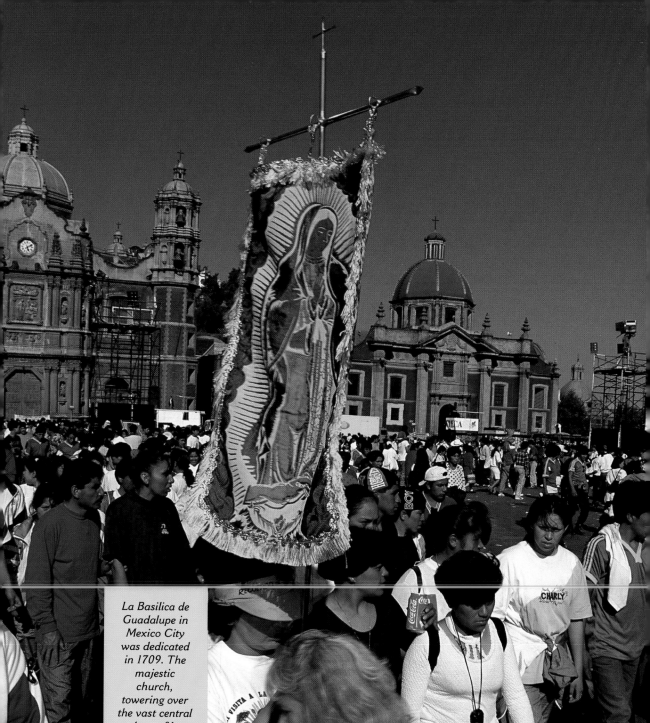

La Basílica de Guadalupe in Mexico City was dedicated in 1709. The majestic church, towering over the vast central plaza of La Villa de Guadalupe, is now closed to the public.

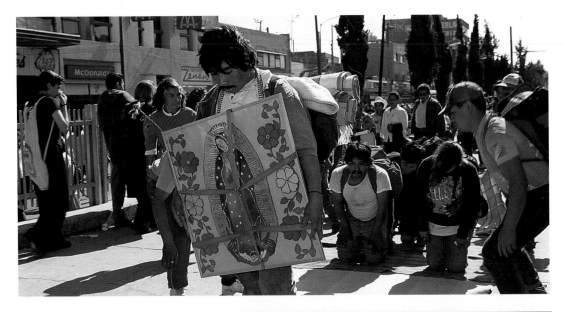

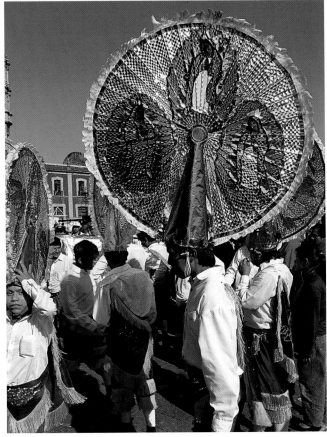

Thousands of pilgrims flock daily to La Villa de Guadalupe. Some end their long journeys on their knees; many bear their household replicas of the Virgin. Dancers in festive costumes perform for the Virgin's feast day.

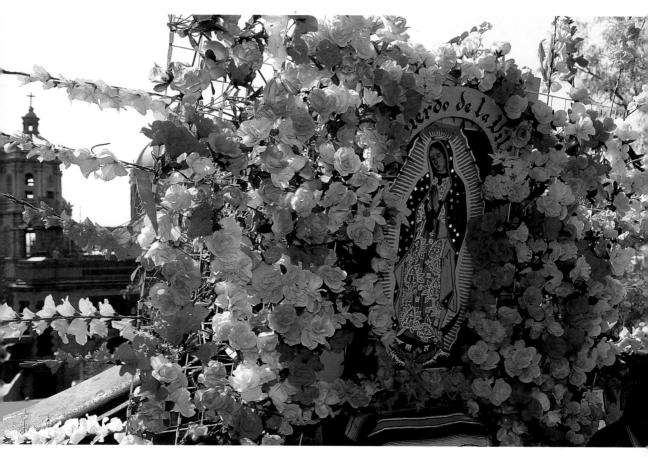

The functional and starkly dramatic new basilica, opened in 1974,
was engineered to withstand earth tremors. It shelters the famous
image of Guadalupe, the "Miraculous Portrait" that is the basis for all
depictions of the Mother of the Americas.

Moorish Arabic of Spain. There have been numerous guesses about the Mexican Guadalupe's name based on a misunderstanding of the Náhuatl language. Not only did the Mesoamerican Náhuas before the conquest of Mexico starting in 1519 have no "d" or "g" similar to these letters in the word Guadalupe, there are far too many words beginning with the root *Guad* used throughout Spain and New Spain to locate the origins of the Virgin's name anywhere but in Iberia.

The statue of the Spanish Guadalupe is tiny, carved from very dark wood, and ornately dressed; she holds an equally dark Jesus on her arm. Folk history holds that Luke may have carved this statue and that Bishop Leander of Spain received it in 599 as a gift from Pope Saint Gregory the Great, but recent research finds no evidence for this lore. The Guadalupe of Mexico is without Jesus on her arm, and her clothing is as simple as depictions of that worn by Mary of the Holy Land. For centuries it has been the artists who have helped form our concepts of Mary's appearance and illustrate her links to certain doctrines, as the Bible is silent about Mary's birth, death, and clothing.

There is a noteworthy relief carving of the Virgin Mary in the Spanish monastery fronting the choir loft that presents the Virgin in the Immaculate Conception tradition, holding the infant Jesus. In this rendering, she is standing on a half-moon that rests on the shoulders of a cherub and is surrounded by a spectacular sunburst, or body halo. Hints of the theological concept of the Immaculate Conception reach back to the second century following the Crucifixion, but the celebration of Saint Anne's conception of Mary as divinely appointed to be the sinless mother of Jesus did not appear on church calendars until after 1128. During the Middle

The Spanish Guadalupe, Real Montasterio de Guadalupe, Cáceres, Spain.

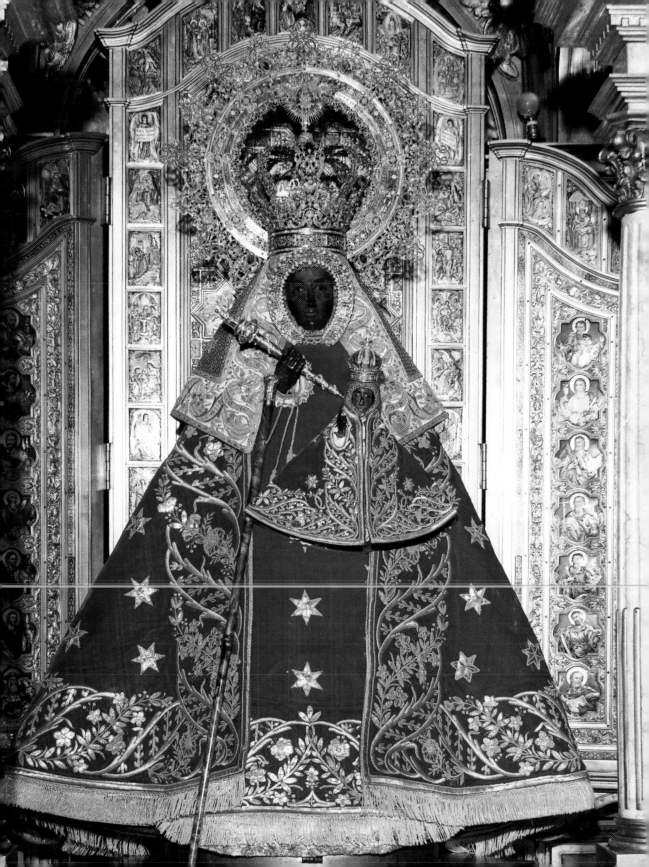

Ages, this church teaching was popularized in the religious art of southern Europe, especially Spain. These early images presented Mary with the Christ Child, and in later depictions, particularly the Spanish works done by the 1600s, she is shown as an *Inmaculada* without the infant Jesus but with her symbolic attributes. The pristine stage of the image of Mary on Juan Diego's tilma reflects the newer and typically Spanish rendering of the Virgin without the Christ Child; the second phase, with the inserted attributes, commingles the Virgin of the Immaculate Conception with the Virgin of the Apocalypse.

Some suggest that the tilma was a copy from the general reservoir of Iberian art circulating about Mexico in the sixteenth century, given that the tilma portrait is certainly part of the childless Immaculate Conception style. Others, more inclined to unquestioning belief in the miraculous portrait of 1531, insist the original composition was not made by human hands and therefore is free of history. There are those who offer the hypothesis, based on early written accounts, that the first Guadalupe of Tepeyac was a silver statue of the Madonna and Child replaced later in the century by the tilma image of the Virgin in her childless Immaculate Conception mode, this work perhaps done by an Indian copyist. However, these skeptics and scholars have not succeeded in toppling Guadalupe from her revered position.

Guadalupe of Tepeyac evolved over the centuries as the master symbol of Mexico. She was invoked for all manner of personal woes and public ordeals such as plagues. The composition of the population who championed her slowly moved from the important European descendants born in Mexico, the *Criollos*, eventually to include the native-born Mesoamericans. By the early 1800s, the nation turned to her to represent the people in their desire to win freedom from Spain. The patriot Hidalgo carried a banner emblazoned with Our Lady of Guadalupe into battle, and the first

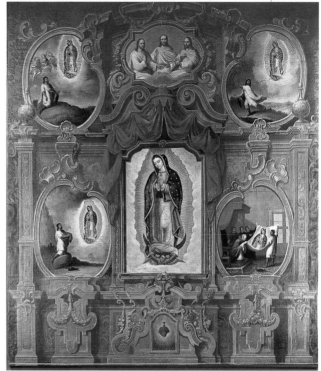

The Santuario de Guadalupe in Santa Fe, an active and cherished center of the community since 1793. Inside the old adobe walls hangs the largest painting on canvas in the United States of Guadalupe, signed by José de Alzibar (Alcibar) in 1793 in Mexico City. (Above: GHF; left: JOD)

president of Mexico, Guadalupe Victoria, took on his patroness's name in honor of the Virgin of Tepeyac after winning a decisive battle in Mexico's war. Today, millions flock to the Basilica of Guadalupe in Mexico City to honor her.

Nobody knows for certain exactly when Our Lady of Guadalupe in her Mexican invocation first arrived in New Mexico as a private devotion. Church inventories, birth and death records, and diaries of famous conquistadores offer no mention of her before 1692, but by September of that year public documents mention her presence in Santa Fe. This date marks the denouement of the most successful

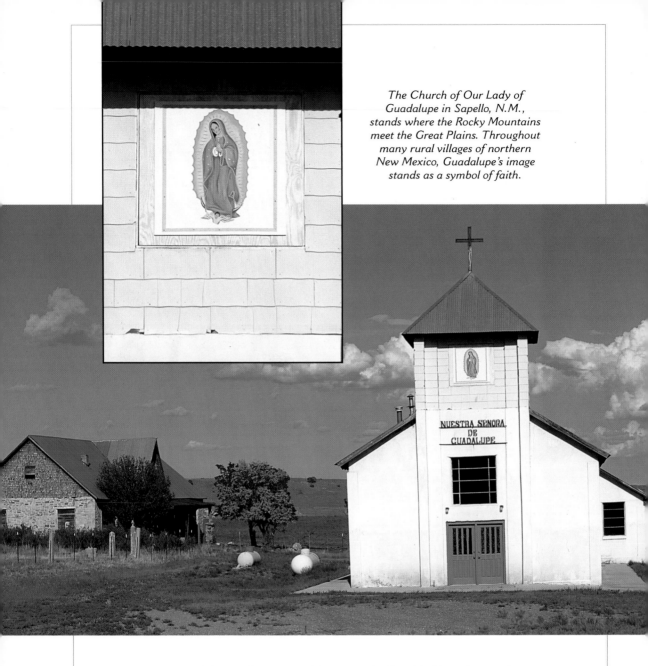

The Church of Our Lady of Guadalupe in Sapello, N.M., stands where the Rocky Mountains meet the Great Plains. Throughout many rural villages of northern New Mexico, Guadalupe's image stands as a symbol of faith.

uprising in Native American history—the Pueblo Revolt—and sets the stage for Guadalupe's growth as a devotion in the United States. Events began in 1680 with the bloody revolt by the Pueblo Indians of the northern Rio Grande Valley against the Spanish who had settled in the area. During this uprising, mission churches were destroyed and civil and religious leaders killed. While Santa Fe

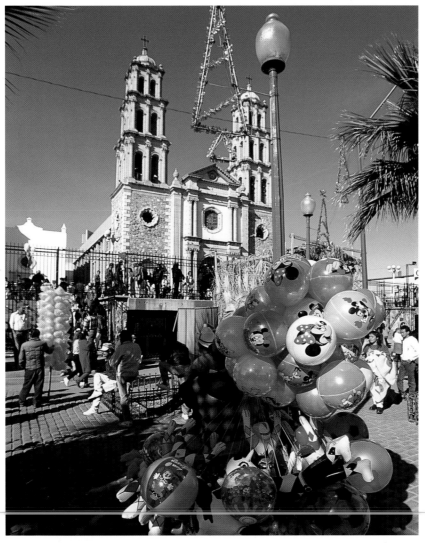

Ciudad Juárez, once called El Río del Paso del Norte, was the gateway for Guadalupan devotion into the Rio Grande Valley in the late 1600s.

burned, settlers from outlying ranches fled for their lives, finding refuge some three hundred and fifty miles south in El Paso del Río del Norte, now the Mexican city of Juárez. There they lived for twelve years near the Mission of Our Lady of Guadalupe. An ensuing devotion developed. For the exiled Franciscan friars, who historically had questioned the early consecration to la Morena, El

Paso may have represented a turnaround in their acceptance of the devotion to Guadalupe.

Near the Mission of Nuestra Señora de Guadalupe at El Paso, the displaced Spanish-heritage people witnessed the native Indians—Mansos, Piros, and Tiguas—dance for the Dark Virgin, make pilgrimages in her name, kneel in reverence before her image, and honor her with feasts and bonfires. These traditions would be transferred to many parts of the kingdom of New Mexico with the reconquest of 1692–93.

Don Diego de Vargas led the return of the Spanish to Santa Fe in 1692. They carried the statue of the beloved la Conquistadora, originally brought to New Mexico earlier in the century. This Marian image also has been called the Virgin of the Assumption and Our Lady of the Rosary (Rosario). Rescued during the Pueblo Revolt, she rode triumphantly with the returning entourage. After he settled his people permanently, de Vargas gave thanks to Guadalupe for their safe *entrada*. From this time, the Mexican Virgin Mary of Guadalupe was forever at home in New Mexico.

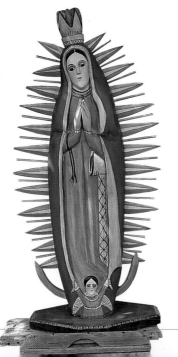

Euliogo and Zoriada Ortega built their private chapel in Velarde, N.M., in gratitude to Guadalupe for restoring Zoriada's health. (Photo: JOD)

Together, the Ortegas created this serene yet vibrant bulto.

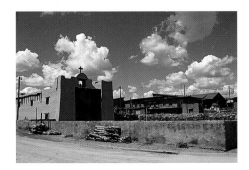

The old Spanish mission at Zuni Pueblo, built in 1694, has been dedicated to various invocations of Mary and permanently to Guadalupe since 1754. (Photo: JOD)

Several factors would establish Guadalupe as the premier Marian devotion in New Mexico. The first was the growth of the local population after 1692 on account of an influx of settlers via Mexico. Many of these pioneers were already supporters of Guadalupe. Although the original Spanish residents of Santa Fe remained loyal in their devotion to la Conquistadora, colonial society was now expanding both with newcomers and detribalized Indians, called *Genízaros*. A second contributing factor in the flowering of Guadalupe's popularity was the Franciscan endorsement, which swelled the ranks of followers among the Christianized Pueblo tribes along the Rio Grande corridor.

With the conclusion of the de Vargas entrada, daily life in northern New Mexico slowly returned to normal and the people busied themselves with farming, herding, trading, and peaceable family life. An early indication of devotion to Guadalupe came with the revival of Pojoaque Pueblo, about sixteen

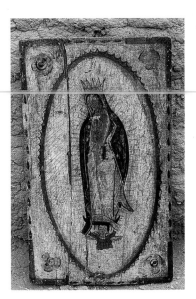

An unknown santero, probably of the late 1790s, left this delicate retablo with Guadalupe's emblem, the rose in each corner, in the old Pecos Mission. (Pecos National Monument, N.M.)

miles north of Santa Fe, in 1706. Governor Cuerbo y Valdés established families on the site of an abandoned native settlement, which he dedicated as the Pueblo de la Nuestra Señora de Guadalupe de Pojoaque, the name by which it is still known today. On December 12, the Feast Day of Guadalupe, established in 1754 by Pope Benedict XIV, this and many pueblos sponsor all-day dancing to celebrate the Virgin.

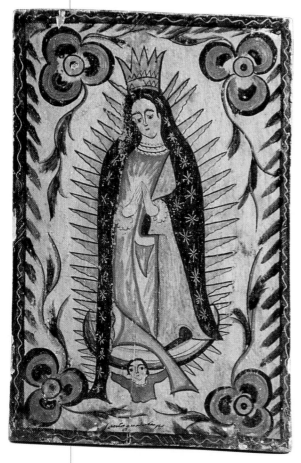

Santero Pedro Antonio Fresquís (1749–1831) of Truchas, N.M., depicted Guadalupe in his hallmark style of a sketchily drawn figure set in an ornate background. (MOIFA)

In 1776, while representatives of the thirteen colonies along and near the eastern seaboard drafted the Declaration of Independence, concurrently in the Southwest Fray Domínguez penned a report listing the artifacts in the mission churches of the kingdom of New Mexico. His study, *The Missions of New Mexico, 1776,* cites twenty-two pueblos (now there are nineteen); eleven of them held images of Our Lady of Guadalupe. Clearly, the power of her gentle spell and her message of compassion had captivated the people of New Mexico.

The Spanish-speaking colonists living in the northern reaches of New Mexico were isolated from their ancestral European cultures and the religious art of those traditions. Some few pieces of sacred art from the Continent and Mexico trickled into the northern Rio Grande area but

not enough to meet the popular demands of an ever increasing population.

To fill the void, local artisans put their talents to the service of depicting images of saints and holy personages. At first, sacred images (*santos*) were drawn on animal hides, as paper was scarce. By the close of the eighteenth century, saintmakers abandoned hide painting and began to carve and paint wood. The late 1700s to the mid-1800s, recognized as the classic era of the *santero* movement, saw a burgeoning of locally produced arts for religious use.

In the past, popular misunderstanding gave credit to Native Americans as the creators of the santos of the period. This is because the works done by these early New Mexican artists who presented Christian themes were rendered in a style so far from the conventions of academic art that they were assumed to be totally alien to European artistic norms and roots; thus, they were

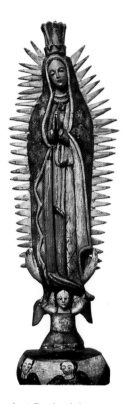

José Raphael Aragón worked in northern New Mexico from about 1825 to 1855. He presents his Guadalupe in a delicate bulto with all her famous attributes. (MOIFA)

classified as aboriginal and, therefore, pagan. The local santero had no way of seeing the great art in Mexico or Spain, and art books were virtually nonexistent. Most santeros relied upon poor reproduction prints on which to base their otherwise unfettered renderings. Their works, while faithful to Christian themes and basic iconography, expressed a unique folk quality heightened by great originality and vitality. Cultural isolation and lack of studio training were factors that allowed for memorable artistic expression. These religious works seem to embody an invisible spirit

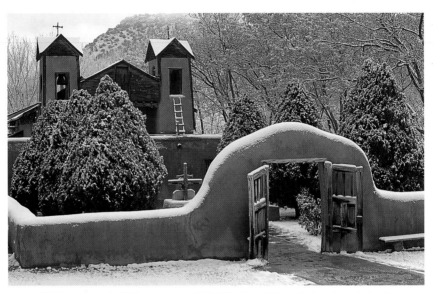

El Santuario de Chimayó, an official National Historic Landmark, is also called the "Lourdes of America." For many pilgrims, it is the final destination in devotions to Guadalupe.

at work inside the mentality of the santero, a force that seems not to come from a material source but rather from transcendent inspiration nourished by spiritual traditions.

The great flow of human history depends on change and social evolution, but daily life and ordinary time depend on repetition. The clock and the calendar regulate our schedules, our holidays, and our newspapers. Eternal time belongs to the supernatural, transcendent realm. This balance between the moving and the static, the sacred and the secular has motivated two different approaches to depicting the Virgin Mary of Guadalupe. One tradition favors renderings close to the image of la Virgencita on the tilma, taken by devotees to be sacred art. The other trend is to present the Virgin in innovative, even startling creations.

A dynamic example of santero art put to the service of glorifying Our Lady of Guadalupe is on perpetual display in a panel set in the north wall of the famous Santuario de Chimayó, often called "The Lourdes

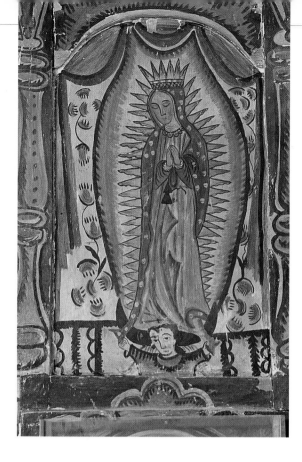

This skillful retablo rests on a panel in the north wall of the Santuario de Chimayó. It is painted by José Aragón, a Spanish-born santero whose signed New Mexico works date from 1821 to 1835.

of America." During the early 1830s, José Aragón painted his Virgin of Tepeyac, an image clearly divergent from the tilma prototype.

In contrast to the dynamic presentation of Aragón, the Santo Niño Santero created a more gentle, composed image of Guadalupe in the same era with a sentimental link to the original. This *bulto* (three-dimensional relief carving), not quite a copy of the tilma, emphasizes the serene qualities of Guadalupe.

The Church of Our Lady of Guadalupe in Villanueva, New Mexico, treasures a charming, delicate bulto of la Morena. Nobody knows who fashioned her or when. Some villagers believe the statue came north from Mexico in the nineteenth century; the image clearly hints that it is the work of a Mexican, and not a New Mexican, santero. It is this bulto of Guadalupe that accompanies the villagers on their processions and pilgrimages and that watches over them during mass.

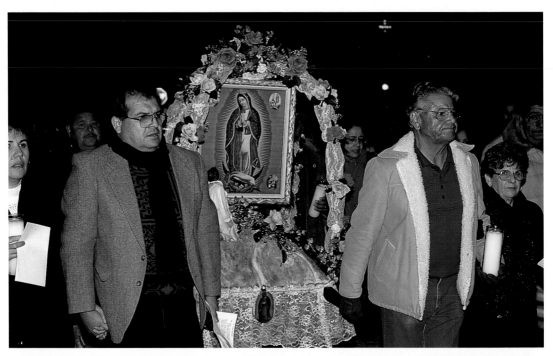

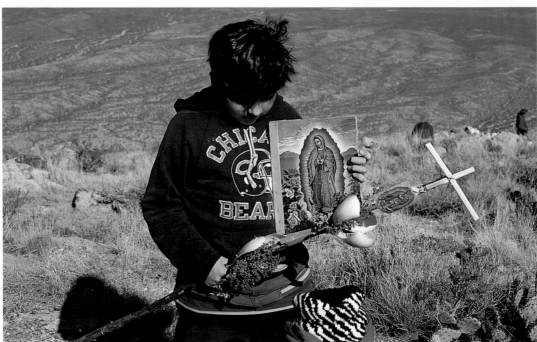

*Pilgrims honor the Virgin of Guadalupe in a three-day celebration
in Tortugas, New Mexico.*

THE ANNUAL PUBLIC PILGRIMAGES undertaken in the name of Guadalupe draw untold thousands of devotees in traditions extending back one hundred and fifty years or more. *Viva Guadalupe!* the pilgrims in New Mexico call out as they walk over the rough high-desert terrain and through merciless sun or thick snow. These faithful followers of the Virgin from Tepeyac are not daunted. They may complain of sore feet and thirst, but they keep one another company by reciting the rosary or singing *alabados*, sacred songs. Most of Guadalupe's devoted followers, some from as far away as Italy and Australia, who undertake a pilgrimage in her name keep a personally cherished image of her with them during their long journeys. Clothing, caps, belt buckles, jewelry, and other items bearing the Dark Virgin's likeness are invariably part of the pilgrims' identification with their patroness. Such votive remembrance is born of a deep conviction that an image bears religious meaning, even protection. Often a pilgrimage leader will fling a banner bearing an appliqué of la Virgencita above them. Inspiration, comfort, and reinforcement of purpose come from the belief that Guadalupe is a pilgrim walking with them, a member of the extended community, a beloved relative at their side. Pilgrimages in the name of Guadalupe are not parades, pious processions, or tours; they are quests that involve a promise (*promesa*) or a vow (*manda*).

The various pilgrimages in New Mexico honoring la Morena are unique in many ways, for they do not conform to the traditional Christian journey of leaving home to visit sacred sites, tombs, or places of martyrdom. Location loyalties are replaced with symbolic loyalty to la Madrecita. No saint, no manifestation of the divine or person from the Bible has ever been associated with the hilltops and the sanctuary that are the goals of the New Mexican pilgrims.

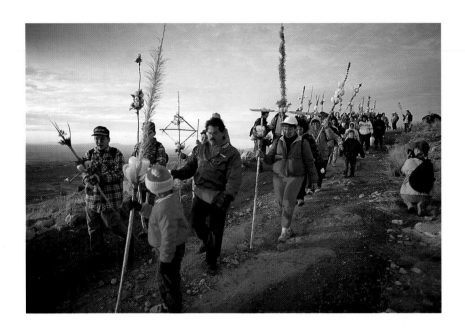

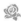

The pilgrimage with the oldest
history in New Mexico takes
place during a three-day
celebration, called a Triduum, for
the Virgin Mary of Guadalupe in
the Tortugas community south of
Las Cruces. A newspaper account
from December 1872 mentions
this event but there is abundant
evidence that the people of the
Mesilla Valley first honored the
Dark Virgin not long after its
settlement in the 1840s. The
Tortugas events draw heavily on
the traditions, reaching deep into
Pueblo Indian culture and
Mesoamerican Ciudad Juárez.

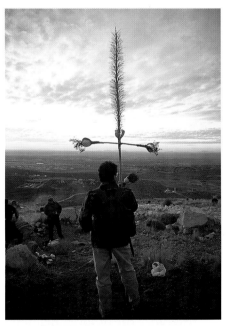

*On the opening evening of the Tortugas
festivities, officials carry their cherished
framed print of Guadalupe through the
streets. The next day, pilgrims climb
the symbolic "Tepeyac Hill."*

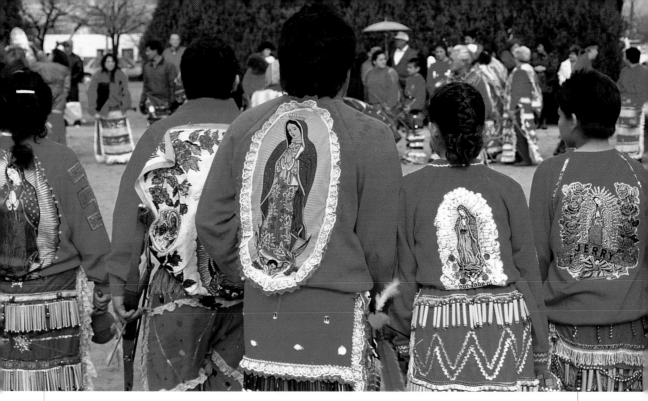

On December 12, the third and final day of the Triduum, the Chichimeca dancers wear red, the color of life and vitality.

After sunset on December 10, community leaders escort their image of Guadalupe, a framed reproduction based on the tilma image, by candlelight from her small chapel through the streets to the nearby community center. The litter upon which she is carried is decorated each year in a different manner but always with a three-dimensional Juan Diego looking upward toward the Virgin. Throughout the night, prayers and dancing pay homage to Guadalupe, and in the blaze of bonfires leading in a northern direction from her native Mexico, a symbolic path between heaven and earth is illuminated.

The next morning, December 11, a ceremony at dawn, *La Alba*, precedes the arduous pilgrimage up Tortugas Mountain, a steep, rocky, four-and-one-half-mile trek. Men, women, and children climb alone or in groups to the summit for midmorning mass, often celebrated by the bishop of Las Cruces. Some walk barefoot or

*A young Azteca Guadalupana wears the sacred color of
corn-cultivating Mesoamericans.*

crawl partway to the fieldstone enclosure lovingly built for the
annual observation. After the service, most pilgrims remain on top
of the mountain to celebrate the joyous but reverential occasion.
During this interval, pilgrims make staffs, called *quiotes*, crowned
with rosettes of yucca leaves, that will help with the steep descent
of this symbolic Tepeyac Hill. At sunset, after the women and
children have returned to Tortugas, captains among the men
traditionally set fire to heaps of tires or wood brought up earlier in
the day to light the pathway for the Virgin to come down the

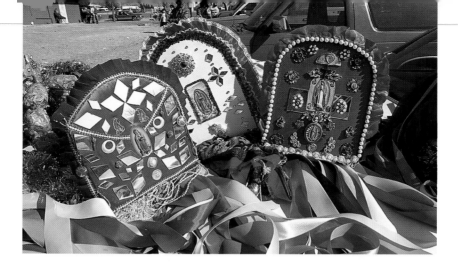

mountain for her annual visit with her people. It is noteworthy that both the pilgrims and the Virgin return to the village along the same pathway down the slope. Bonfires and singing close the pilgrimage that converts this harsh setting into holy ground.

The residents of Tortugas celebrate the official Feast Day of Guadalupe with an overflowing burst of joy and energy. Four different troupes dance to honor their community patroness throughout the third day in areas flanking the Shrine and Parish of Our Lady of Guadalupe. In front of the Shrine and Parish, *los Danzantes* perform Matachines dances, which portray a figurative struggle in which the forces of evil are defeated by the ultimate power of good, an ideal exemplified by Guadalupe. Each member of this all-male group wears an arch-shaped hat reminiscent of a liturgical miter. These headdresses are

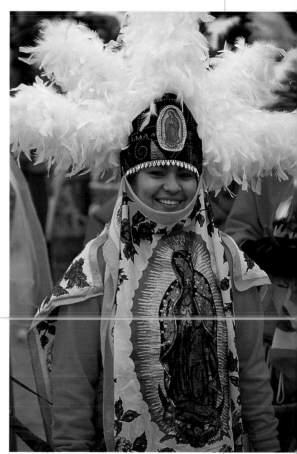

The Danzantes who perform Matachines dances wear stunning miter-shaped hats that are often passed from generation to generation.

The residents of Villanueva honor the presence of Guadalupe in a special pilgrimage held annually on or near August 15, the Feast Day of the Assumption of the Virgin Mary.

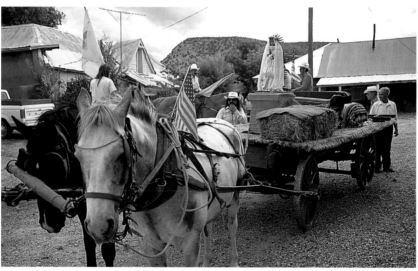

handmade and usually passed from a dancer of one generation of a family to the next as heirlooms. A Pueblo dance troupe, comprised of men and women, rotates with *los Danzantes*. The women carry arrows without tips as an outward token of nonviolence. Dancers dressed in dominant reds of the group *Aztecas del Carrizo*, also known as the *Chichimecas*, draw on Mexican and Indian traditions. Throughout the three-day festivities, aspects of the legend of Guadalupe are reenacted with a mixture of solemnity and exuberance.

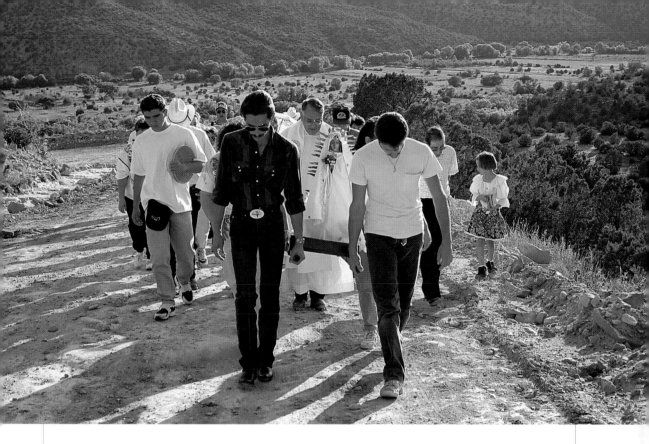

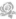

The village of Villanueva, in San Miguel County, celebrates
Guadalupe with a communal pilgrimage on or near the Feast Day of
the Assumption of the Virgin Mary, August 15. During the
afternoon of the celebration, the townspeople and a few welcome
outsiders gather at the front of the church to escort their diminutive
Guadalupe *bulto* up an unpaved road to a hilltop shrine. Some years
she is carried by hand; in others she is placed on a stand set in a cart
pulled by a tractor. In the manner of a European pilgrimage
reminiscent of the Middle Ages, the priest precedes the images of
Guadalupe and the townsfolk follow behind, mostly on foot but
with a few mounted on horses, up a dusty gravel trail and past the
Stations of the Cross mounted at the roadside.

Guadalupe of Villanueva owns a large wardrobe of outfits that
are kept in a trunk. Over the years, the village women have

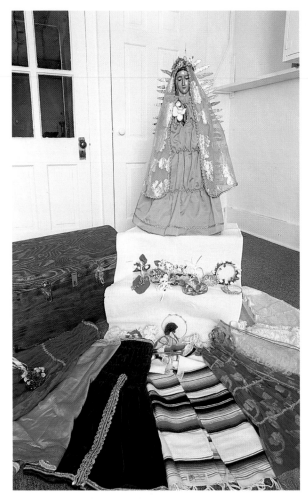

The women of the parish at Villanueva personalize the bulto of Guadalupe by stitching her a special wardrobe.

lovingly stitched her robes: One woman cut her wedding dress to fashion a tiny white lace dress for the Virgin; a visitor brought green silk from Rome for the Villanueva Guadalupe; and sometimes the town women clothe their Guadalupe in a brightly striped Mexican ensemble.

The residents of Villanueva also honor Guadalupe in other ways at other times. In the evening of December 11, the villagers form a procession around the most important building in the town, the Church of Our Lady of Guadalupe, built in the early 1800s. They

take their beloved bulto out of her *nicho* in the church and walk with her through the freezing, often snowy night. Facsimiles of the Dark Virgin stand watch in the local graveyard, and a roadside nicho near the church shelters the Virgin as she silently blesses the cliffs and farmland.

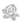

In 1979 a priest in Taos met with women in his parish who were interested in organizing a pilgrimage to honor the Virgin Mary of Guadalupe in her Mexican invocation. A similar practice started in the early 1970s by male pilgrims (*peregrinos*) in the Estancia Valley provided a model. The *Guadalupanas*, as the women pilgrims called themselves, selected the Santuario de Chimayó as their goal. Although not directly associated with Guadalupe, the Santuario's role in miraculous cures fits well into the devotion of la Morena. These women, under their invocation of Guadalupe, wished to celebrate Christian values and promote a calling to Catholic vocations. In turn, this project inspired other women's groups in the Archdiocese of Santa Fe.

Each year on the Saturday before Mother's Day, hundreds of Guadalupanas representing the parishes and pueblos spread across the vast archdiocese make their pilgrimage to the Santuario de Chimayó. Well before sunrise, they start their journeys from the towns of Cordova, Pojoaque, Trampas, and Truchas, singing religious songs and reciting the rosary. Each group walks single file, led by a standard-bearer who holds a banner with her community's particular image of Guadalupe. The pilgrims wear tunics or shirts that identify them with their local parish or pueblo.

Before noon, a throng of friends and family greets the women pilgrims as they enter the courtyard in front of the Santuario de Chimayó. Guitarists make music as the women pass through the sanctuary for a blessing upon reaching their goal. The

*The Santuario at Chimayó is the
destination for pilgrims and lay societies of
devoted followers of Guadalupe.*

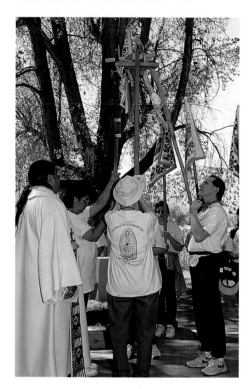

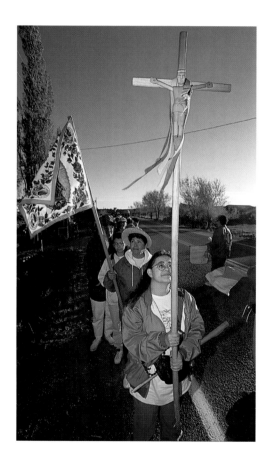

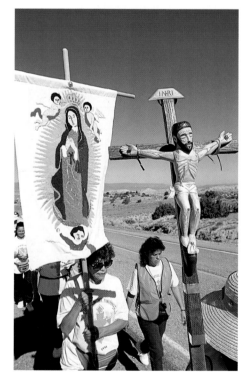

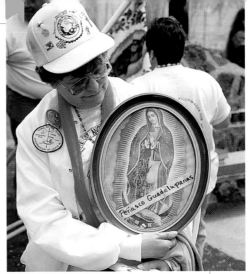

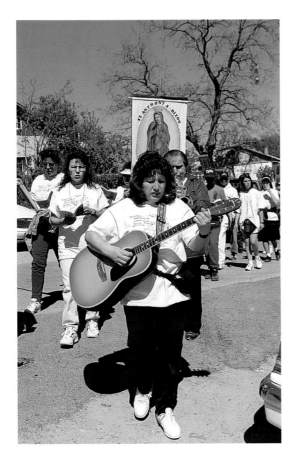

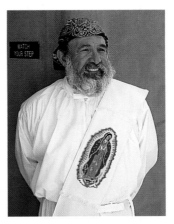

Guadalupanas enter the final phase of their vocational pilgrimage as they walk to the outdoor amphitheater behind the Santuario. Each parish or pueblo leader places its identifying banner next to a cloth-covered altar under a vault of trees; mass follows with a mention, during the homily, of Guadalupe's care for the Guadalupanas and all others who invite her into their lives.

On the Saturday before Father's Day in June, or a Saturday close to it, the male counterpart of this celebration, the *Peregrinos*, converges from the four cardinal directions at the Santuario de Chimayó. These men complete pilgrimages of up to four days'

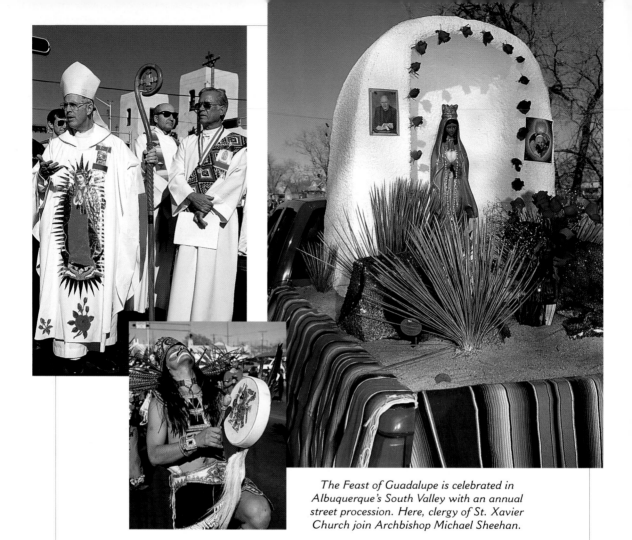

The Feast of Guadalupe is celebrated in Albuquerque's South Valley with an annual street procession. Here, clergy of St. Xavier Church join Archbishop Michael Sheehan.

duration with little to sustain them beyond faith and the purpose of calling men into Catholic vocations with the help of Our Lady of Guadalupe.

The Peregrinos camp along their different routes, some from a distance of three hundred miles or more from the Santuario. Devotees of Guadalupe offer them shelter and food along their often arduous route.

The reunion of the Peregrinos at the end of their pilgrimages is similar to that of the Guadalupanas. Leaders of each group touch

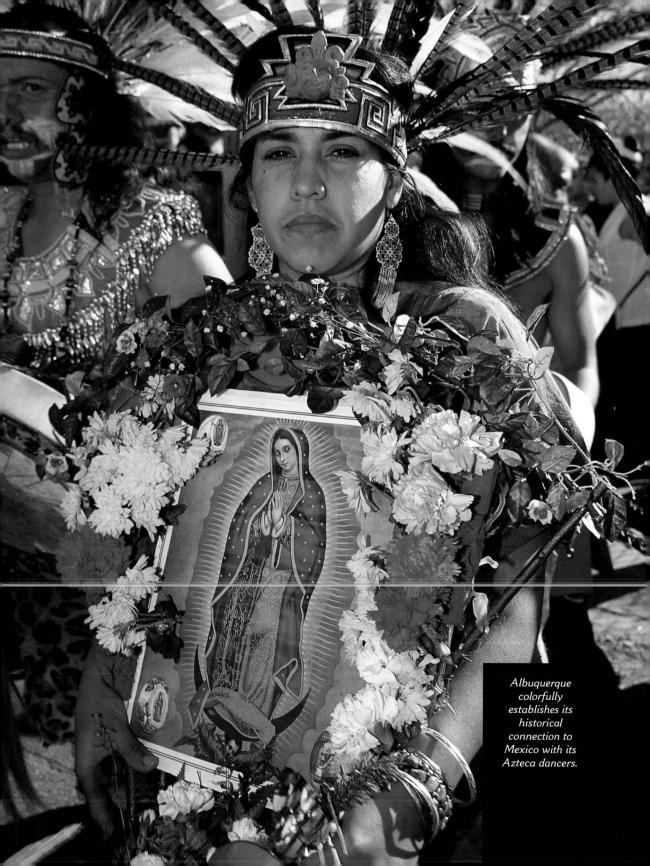

Albuquerque colorfully establishes its historical connection to Mexico with its Azteca dancers.

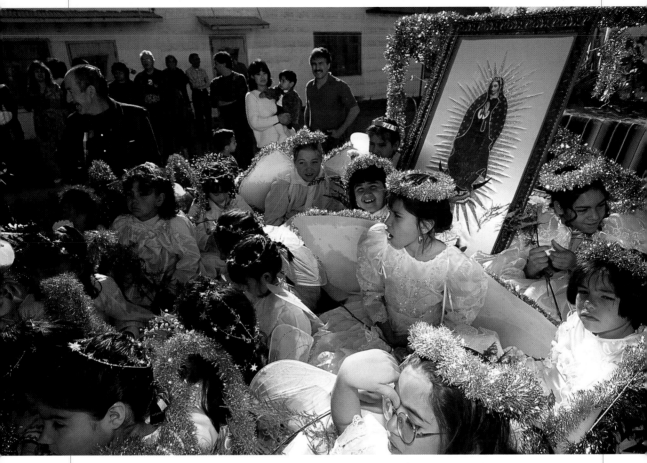

Young would-be angels, wearing tinsel halos, join the street procession.

the tips of their crosses in symbolic union of their solidarity of faith and in the purpose of pilgrimage. Family, friends, spouses, clergy, and a few visitors provide a festive return, and guitarists provide music. A blessing from the clergy at the altar rail inside the Santuario affirms the personal merit of the effort, which has been dedicated to the service of the Catholic church. The mass in the woodland area reinforces the faith demonstrated in the quest. The

As far back as 1659, lay followers and churchmen have celebrated December 12 at El Río del Paso del Norte, now Ciudad Juárez. Joy and piety mark the annual event held in front of the Catedral y Misión de Guadalupe.

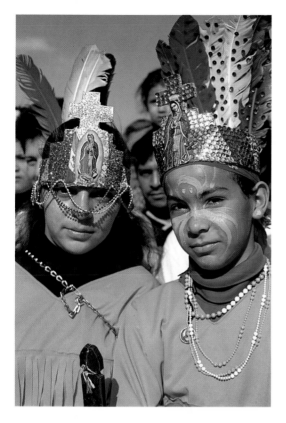
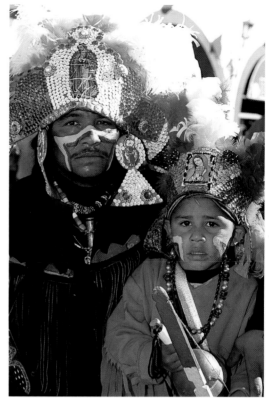
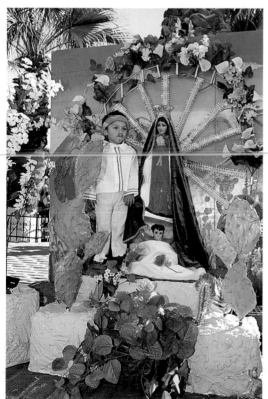
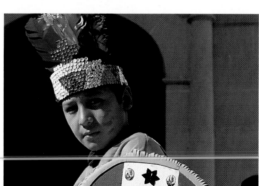
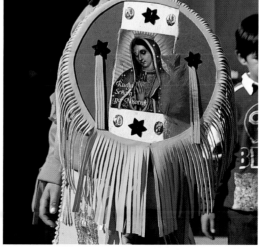

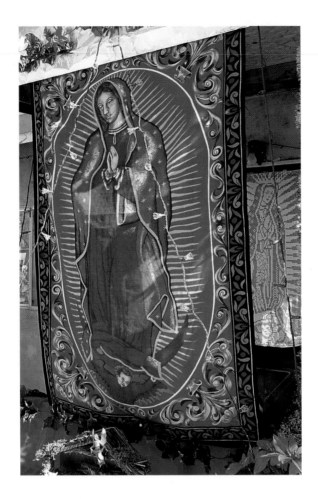

banners of each Peregrino group are placed near the altar under the canopy of trees, and Guadalupe is thanked openly for her inspiration and transcendent presence.

Such pilgrimages express the religious folk traditions of New Mexico with Christian roots in Mexico. In May 1987, the archbishop of the Archdiocese of Santa Fe announced that Guadalupe was not only the Marian invocation of the day but the permanent patroness of his flock in New Mexico, confirmation of a status and connection already well understood by generations of New Mexicans.

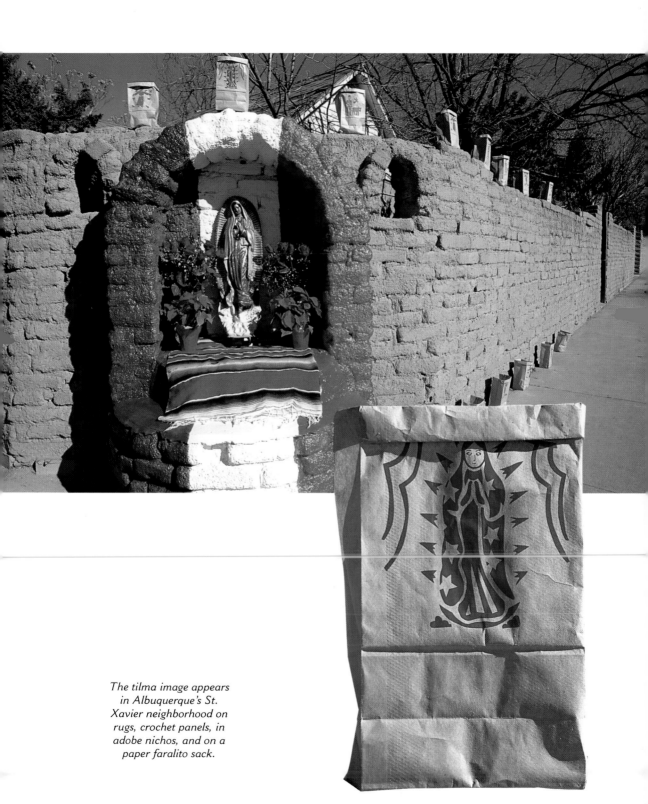

The tilma image appears in Albuquerque's St. Xavier neighborhood on rugs, crochet panels, in adobe nichos, and on a paper faralito sack.

41

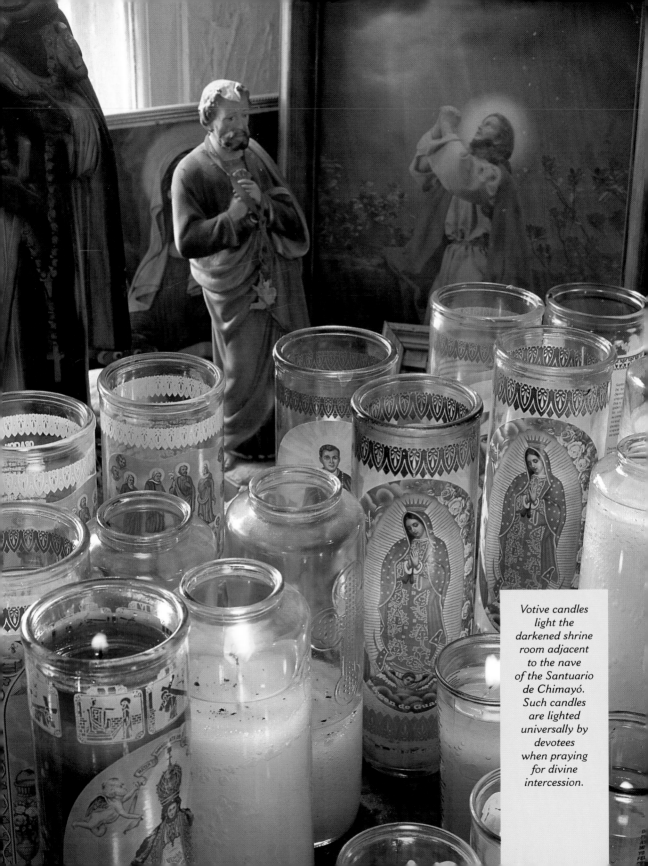

Votive candles light the darkened shrine room adjacent to the nave of the Santuario de Chimayó. Such candles are lighted universally by devotees when praying for divine intercession.

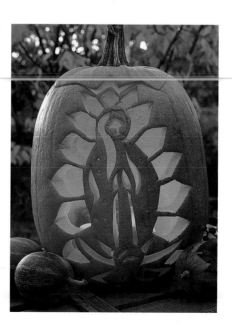

W HAT DOES GUADALUPE MEAN for "all folk of every kind," as the narrative relates she assured Juan Diego? For those who venerate her, she stands for faith, hope, charity, loyalty, protection, and unfailing loving kindness. Guadalupe is seen as one who sets aside punishment to express compassion, not condemnation, for human failings. Her devotees place trust in their ultimate Mother that she will be there to help, cure, and protect them. It is Guadalupe to whom they address their pleas for intercession. Her followers include her in their households; she journeys with them not only across the land in pilgrimages but beyond this life into a hoped-for eternal life.

To artists and craftspersons, past and present, goes an immeasurable debt for expanding the cultus of Guadalupe in New Mexico. Her image is kept alive in the visual arts; her meaning is reinforced by the performing arts. Guadalupe is visible in such abundance that she comes to the viewer at most every turn. Her likeness is permanently recorded in memory.

The social scientist and historian interpret Guadalupe of Tepeyac as an agent for social integration. In this view, religion works not

Artist Ann Mehaffey fashioned a Guadalupe pumpkin.

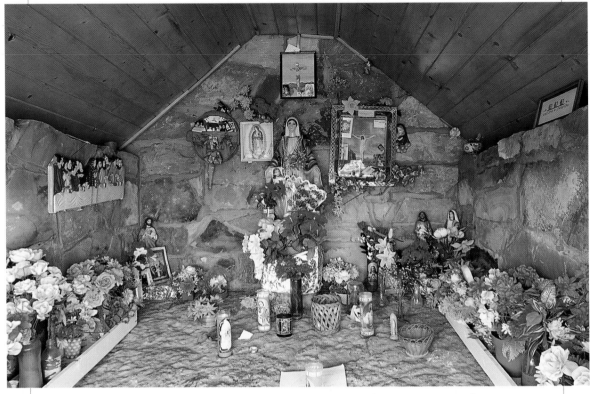

A roadside shrine on a New Mexican backroad outside Las Vegas invites the passerby to enter into the presence of Guadalupe.

only on behalf of individual salvation but to bind people into a community with a shared understanding of the sacred realm. The historian interprets Guadalupe's symbolic function as a unique national emblem that developed to become the ultimate and unifying concept that eventually differentiated Mexico from Spain. In New Mexico, scholars recognize that the Dark Virgin from south of the border was a powerful symbol for evangelizing and for ethnic bonding.

Faith in and familiarity with a recognized religious symbol serve to set standards for votive behavior. In the instance of the Virgin Mary of Guadalupe, it is not the debatable details of the story or the

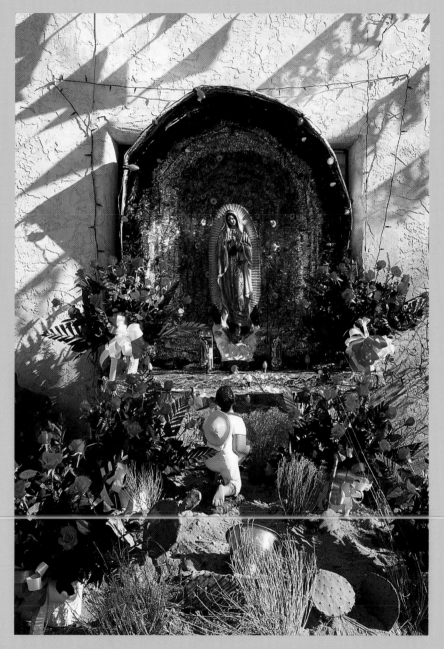

*This front-yard shrine recaptures the moment when the Virgin
Mary of Guadaupe appeared to Juan Diego.*

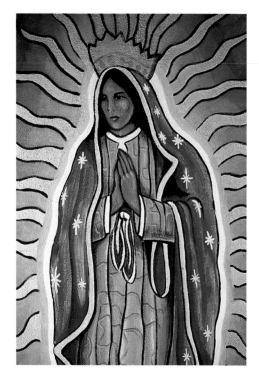

accuracy of the history surrounding it that matter to her followers. It is that she is a familiar symbol and a real Marian presence for them, as she was for their ancestors.

In New Mexico during the twentieth century, Guadalupe has cut across language barriers, ethnic prejudices, age groups, regional factions, and, in fact, religions. Her devotion is to be found in every corner of the state; her image and likeness are ever present.

Guadalupe watches over motorists and passengers who pass her image on a mural along Agua Fria Street, Santa Fe.

There is no single factor, from the words of the scholar or from those of the religious devotee, that can explain the depth and tenacity of belief in or respect for the Virgin Mary of Guadalupe in her Mexican invocation. The Catholic church, local traditions, Native Americans, Mexican history, the universal need to believe in some force greater than oneself, artists of all disciplines, and the power of individuals when they unite behind one symbol have made Guadalupe the most widely honored presence of the Virgin Mary in New Mexico.

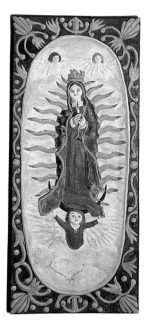

Carved retablo by Gilbert J. Montoya, Jr. (Photo: GJM)

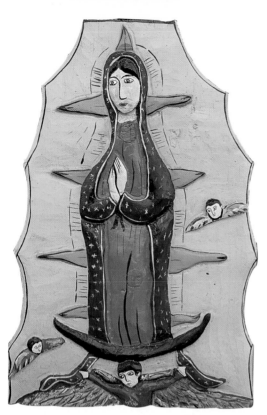

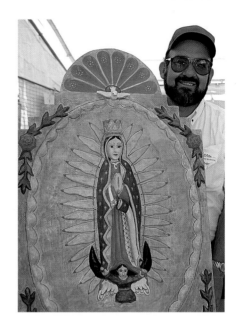

New Mexico artisans, each with highly personal style, give their talents to depicting la Madrecita. Clockwise, top left: José Cipriano Rez; Ernie Lujan at Spanish Market, 1996; Marie Romero Cash at Spanish Market, 1996.

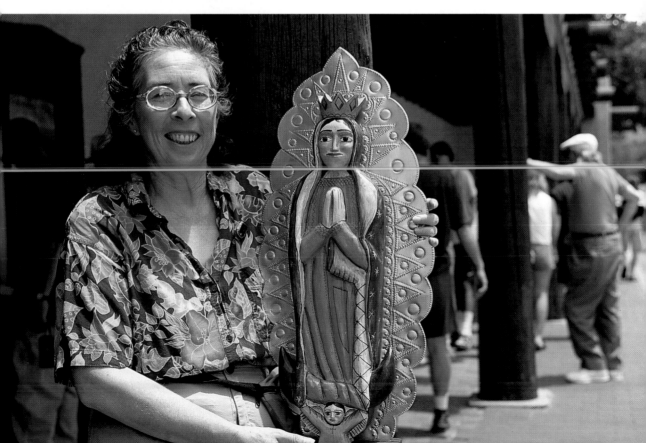

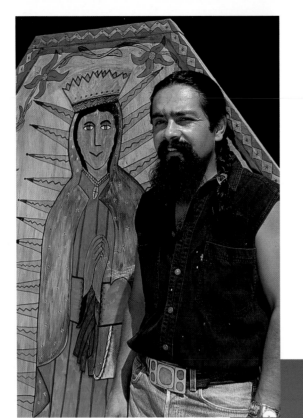

New Mexico has a rich
heritage of artists who
transform their personal
responses to Guadalupe
into unique artistic
creations. Clockwise,
top left: Artist Nicholas
Herrera; artists Celina
and Christina Miera;
chest of drawers
decorated by
Lena Bartula.

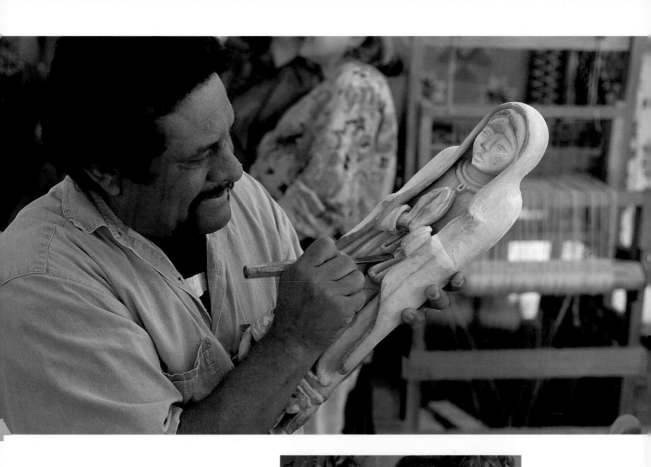

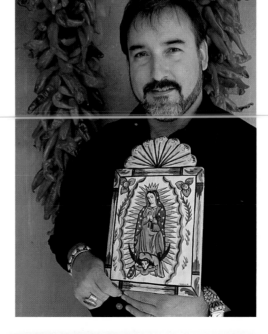

First held in 1926, Santa Fe's annual Spanish Market is the largest exhibit of traditional Hispanic arts in the United States. José Benjamin Lopéz (top) cradles his Guadalupe-in-progress. Charlie Carrillo offers his retablo for collectors to consider.

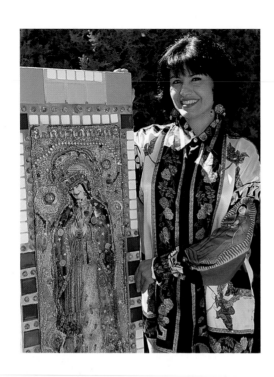

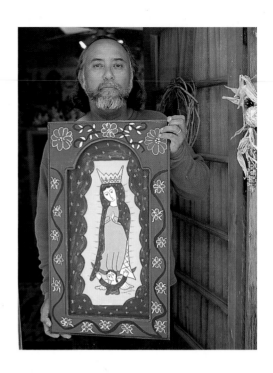

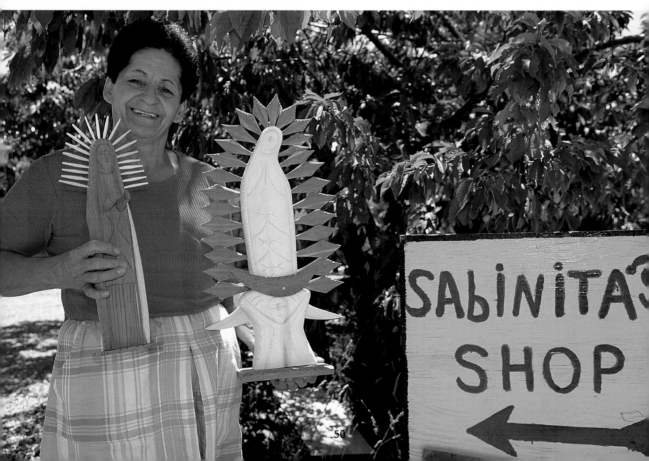

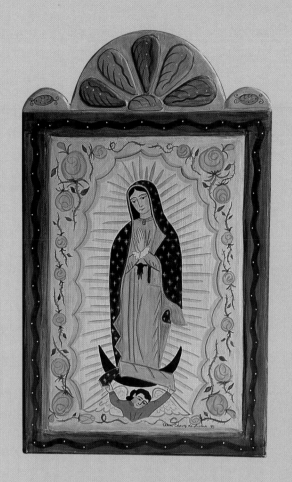

Previous page, clockwise, top left:
Three native-born New Mexican
artists dedicate their imaginations
and talents to la Virgen
de Guadalupe:
Goldie Garcia, Richard Montoya,
and Sabinita López Ortiz.

Above: Santera Ellen de Chavez
Leitner created a sweet, pensive
Guadalupe. Diane Bryer's greeting
card portrays Guadalupe as a
humble Mexican woman.

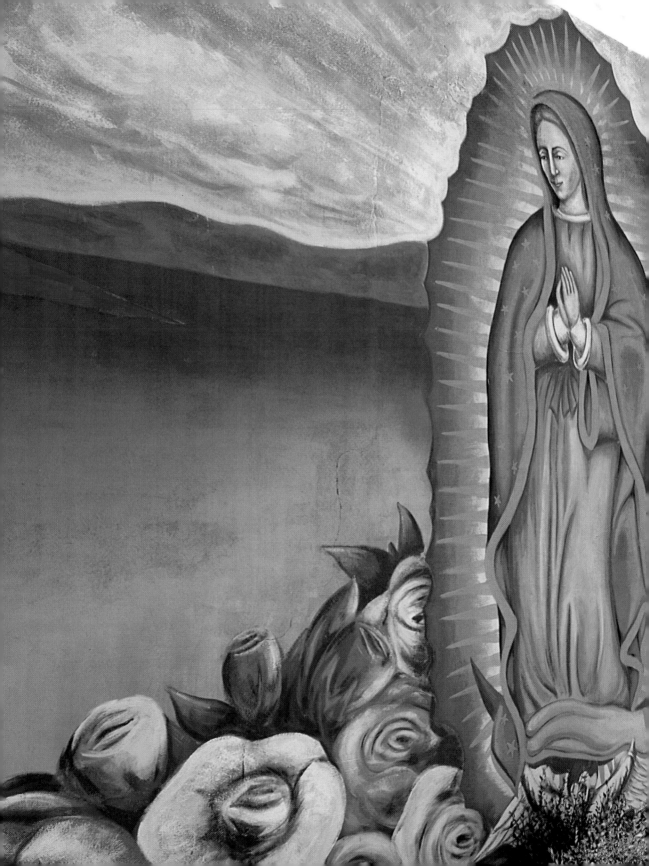

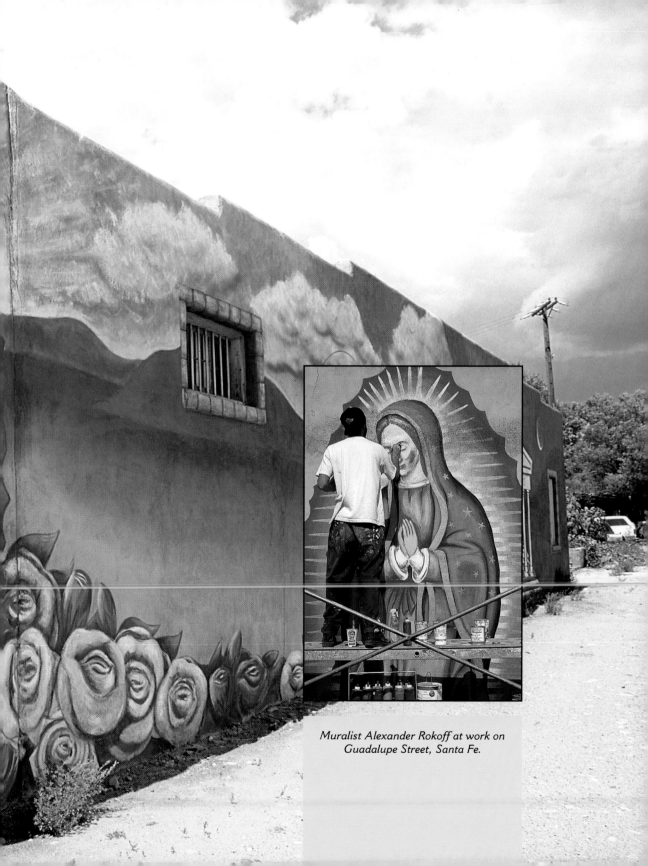

*Muralist Alexander Rokoff at work on
Guadalupe Street, Santa Fe.*

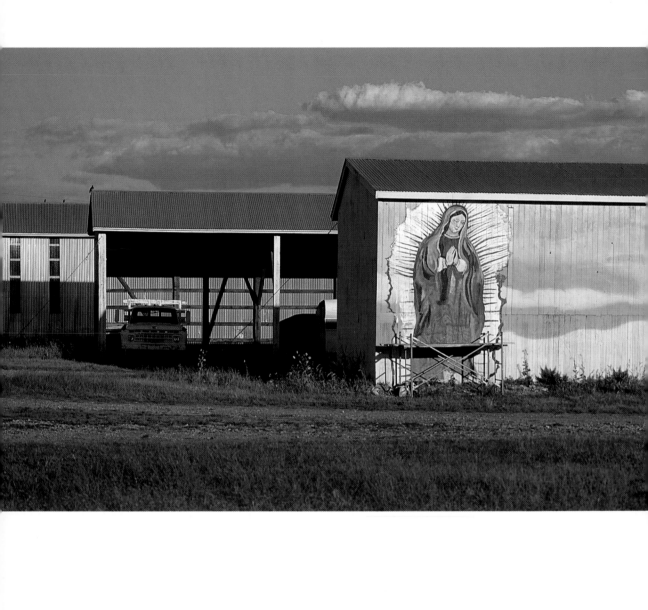

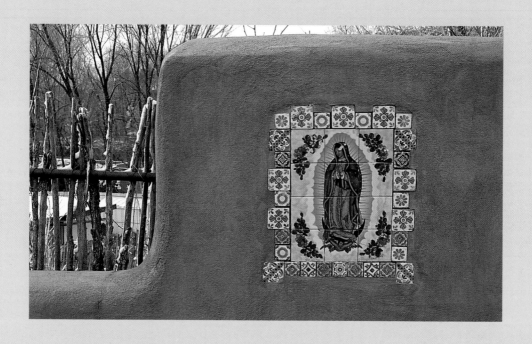

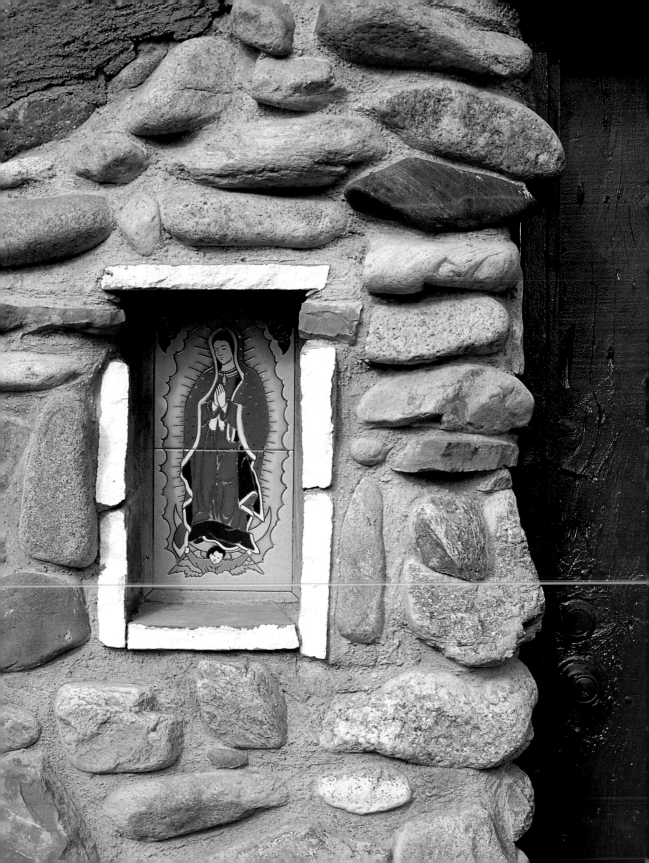

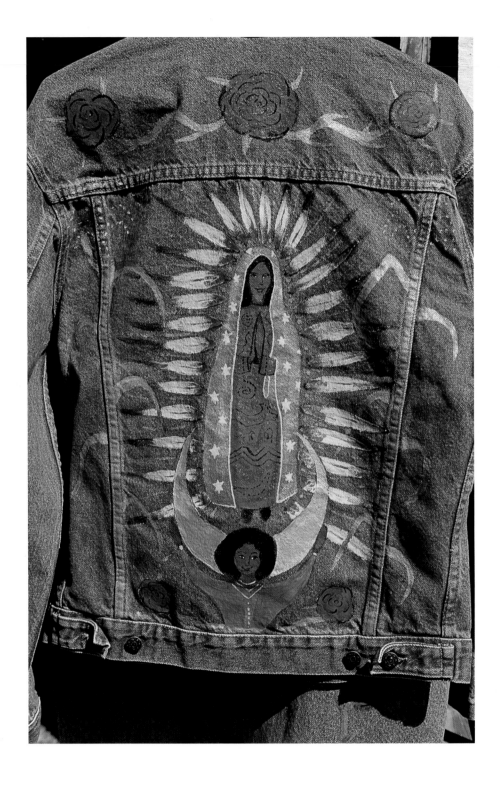

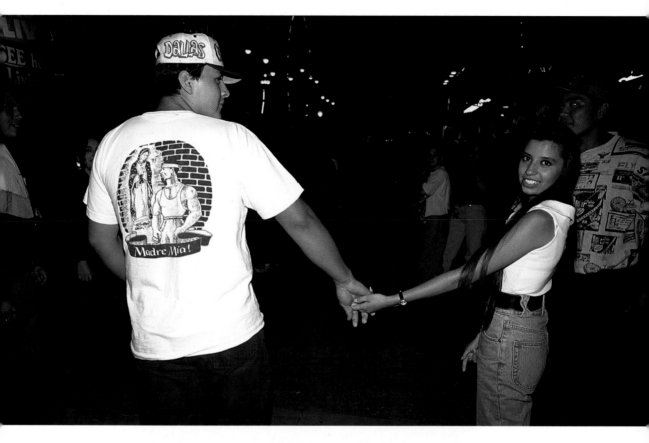

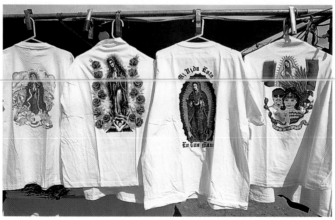

*Under the influence of Guadalupe, faith becomes popular
fashion. Jean jacket by Hannah Wiseheart.*

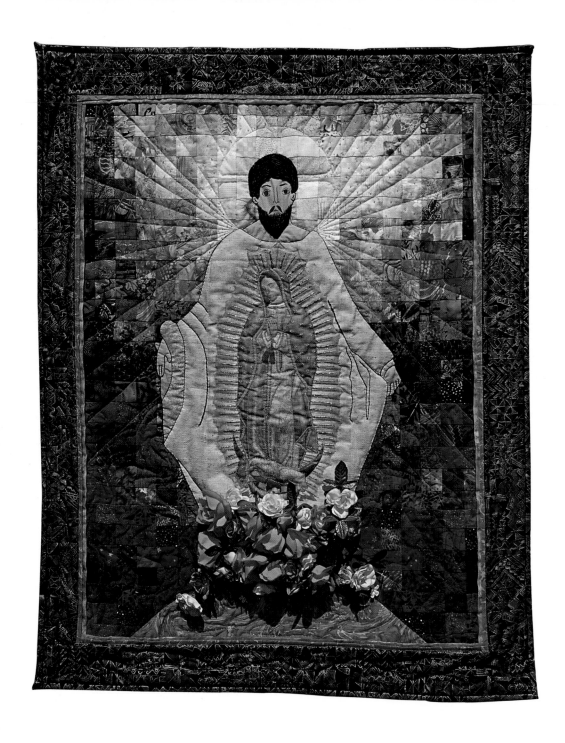

Whimsy and a keen sense of color bring life to folk and commercial art using the Guadalupe theme. Quilt by Vicki Chávez.

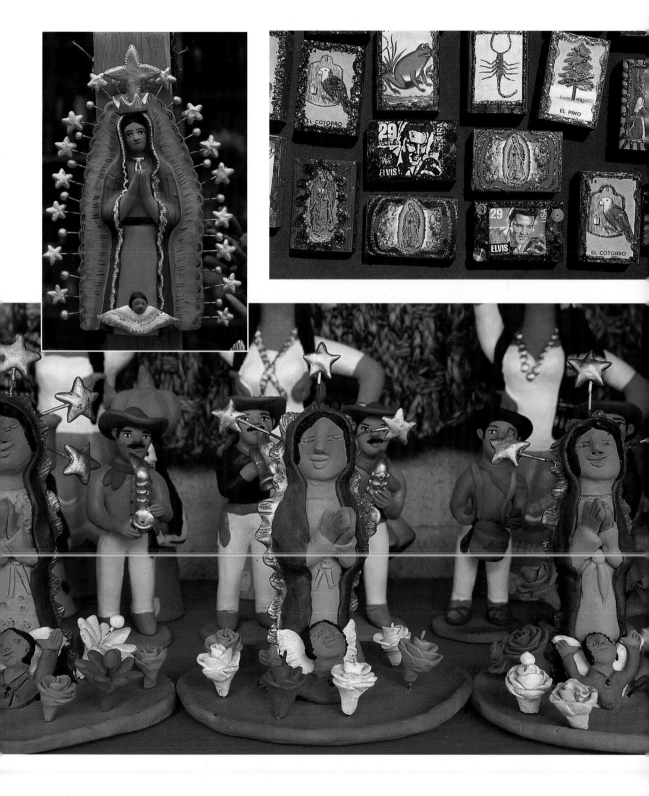

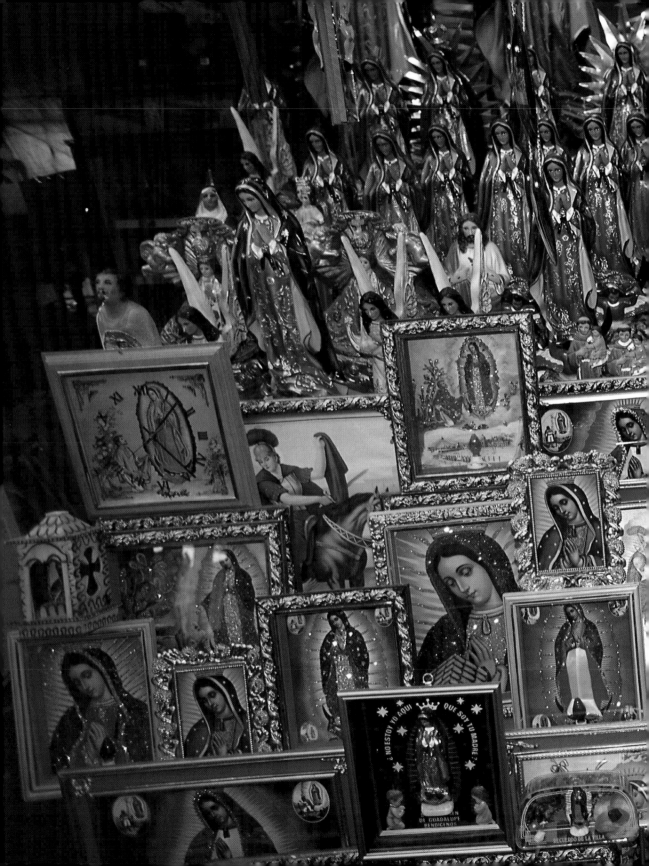

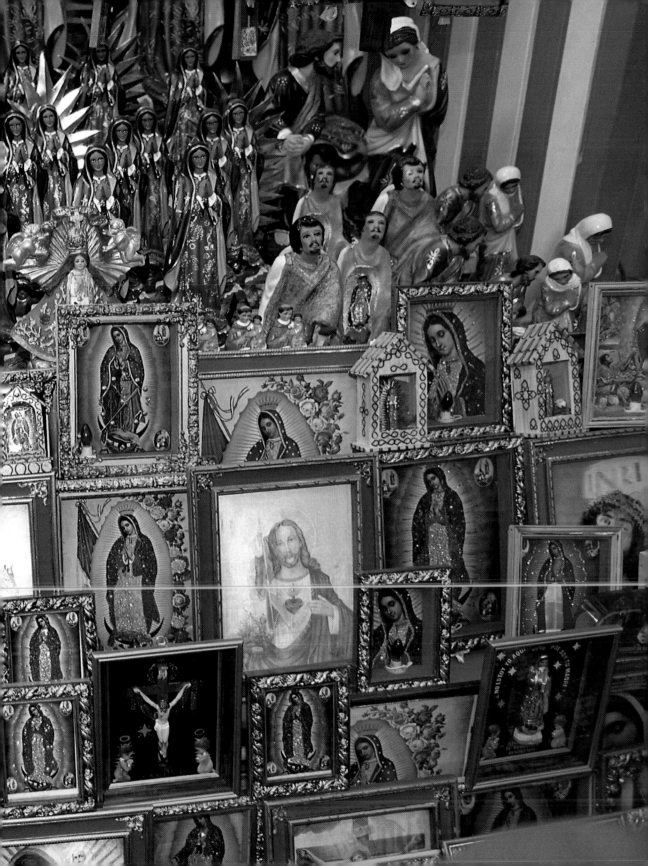

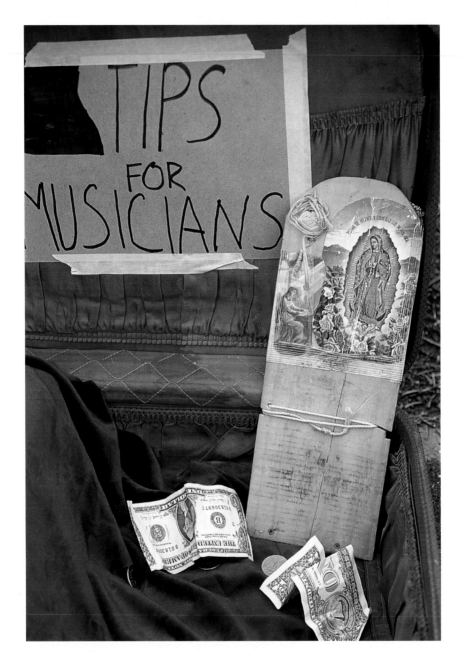

Guadalupe follows those who invoke her in their worldy struggle.

Right: With a background image of Guadalupe as inspiration, a young musician helps band leader Al "Hurricane" Sánchez make music at the annual Velarde apple festival in September.

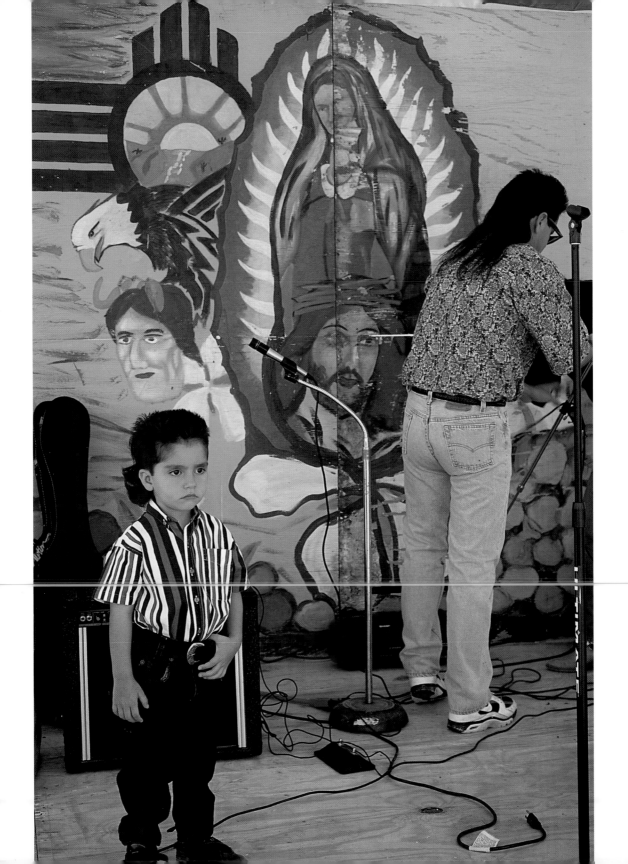

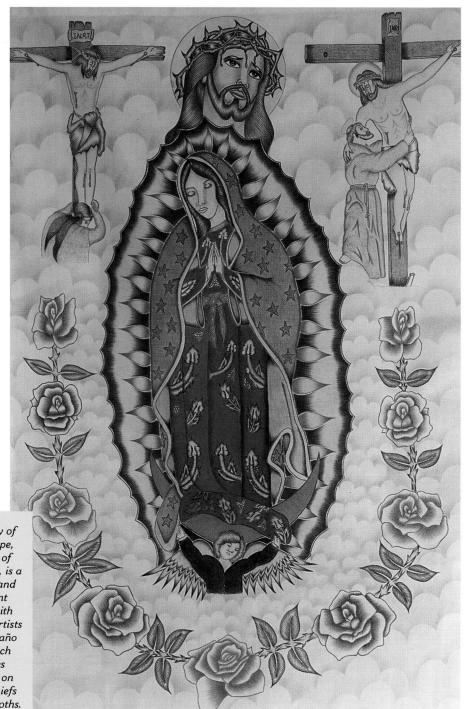

Our Lady of Guadalupe, emblem of protection, is a popular and poignant theme with prisoner artists in their paño art, which features painting on hankerchiefs or other cloths.

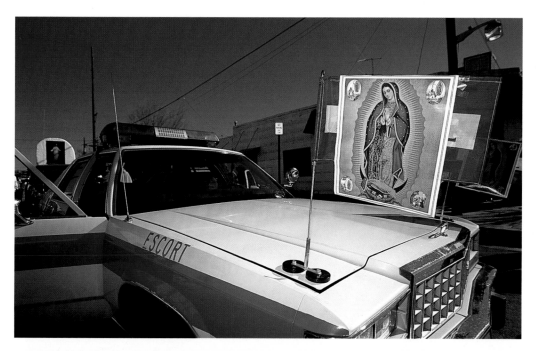

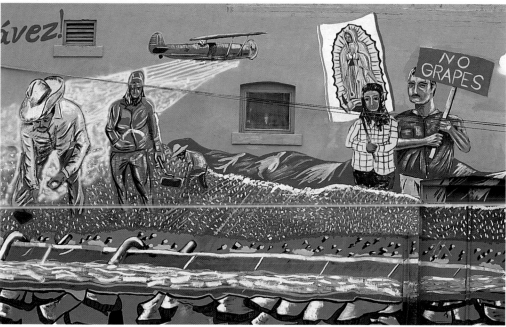

A flag flies from the antennae of a police car in the South Valley of Albuquerque during the December 12 procession.

Oppressed agricultural workers in the southwest looked to Cesar Chávez (died 1993) to secure them justice. He, in turn, turned to Guadalupe to champion his cause.

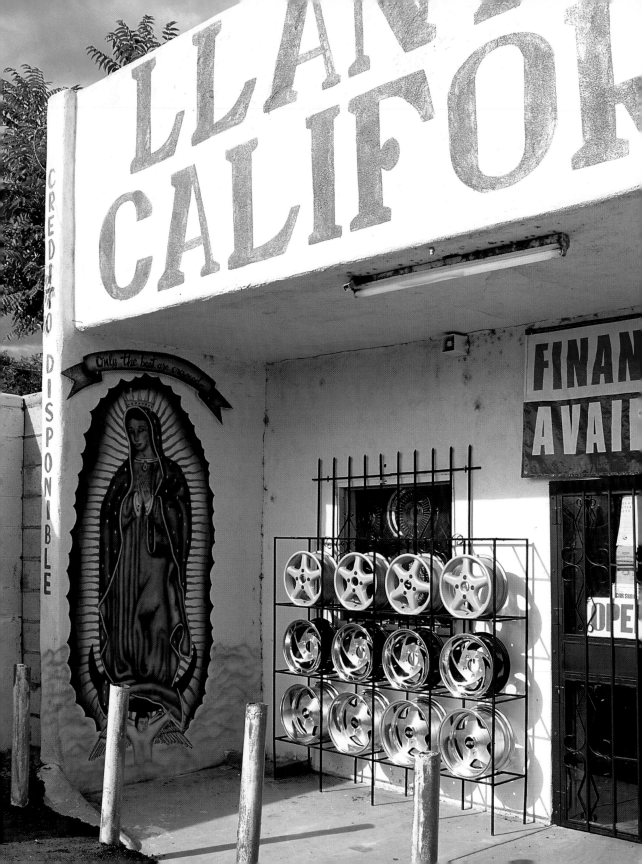

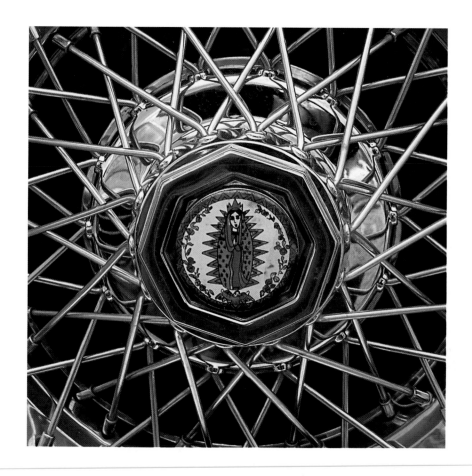

Left: A tire shop in Española reminds that "Only the best are crowned."

A tiny image of Guadalupe by artist Victor Martínez, gleaming from inside a hubcap, provides the driver of a lowrider with heavenly insurance.

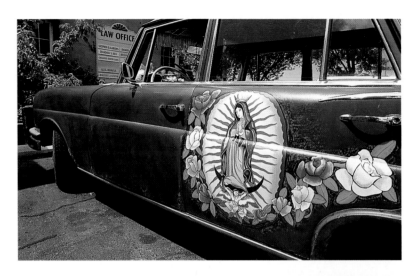

New Mexico cars with an image of
the Virgin of Guadalupe are
transformed into "rolling temples."
Right: artist Randy Martínez;
below: Victor Martínez.

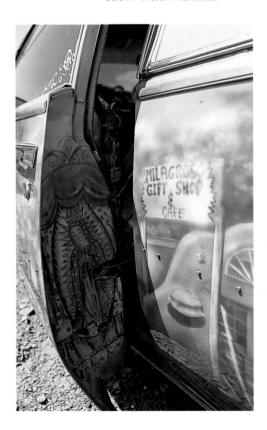

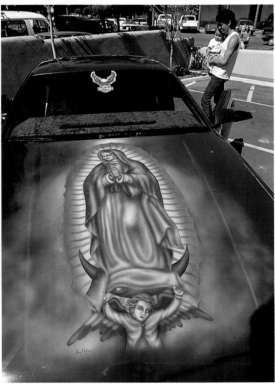

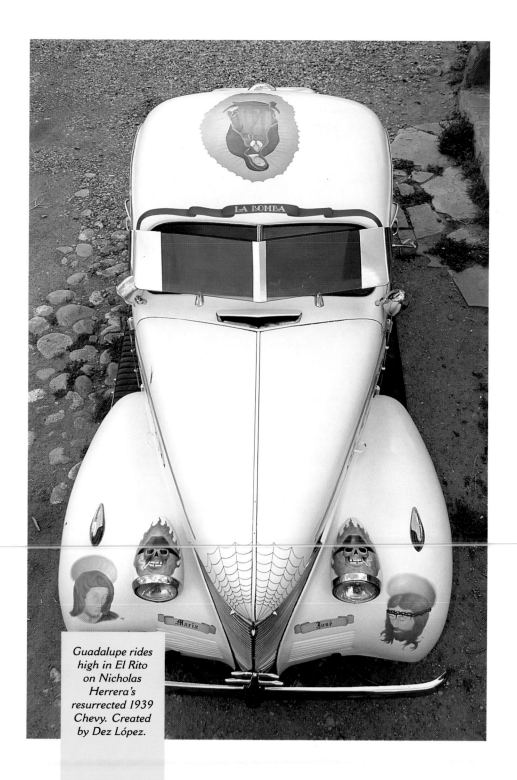

Guadalupe rides high in El Rito on Nicholas Herrera's resurrected 1939 Chevy. Created by Dez López.

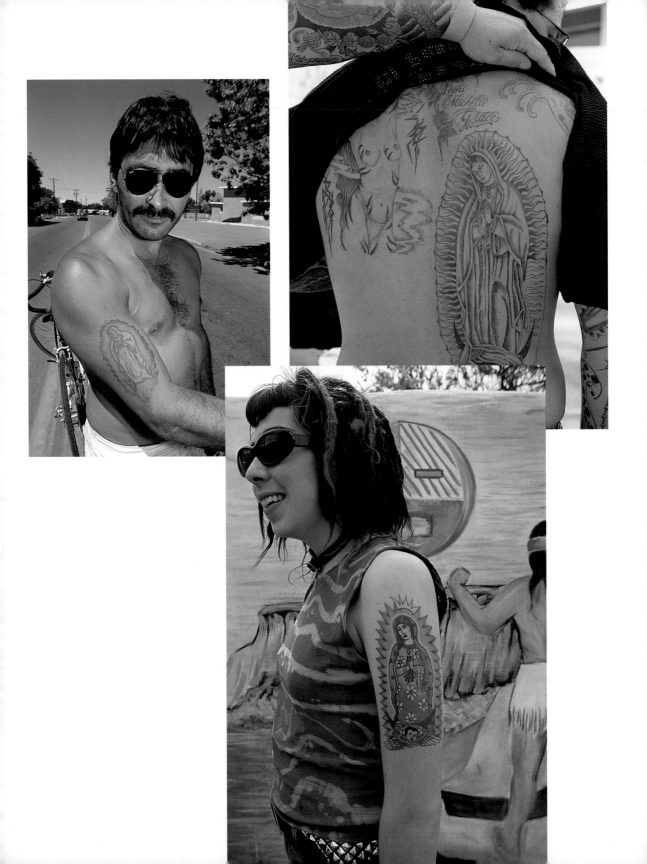

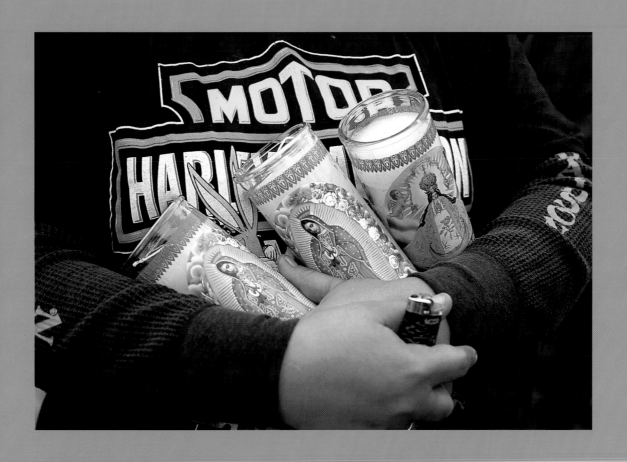

*Guadalupe as symbol mixes
piety with the prosaic.*

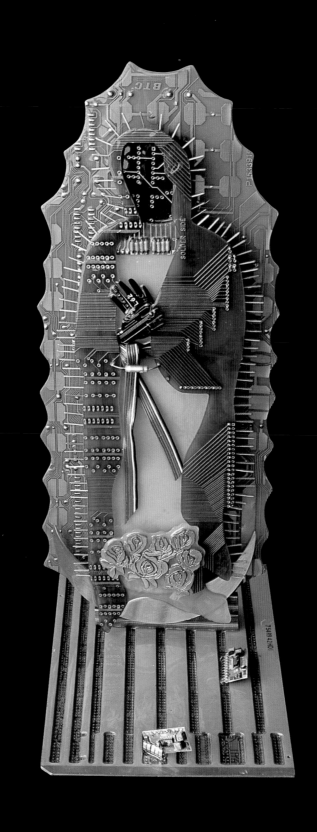

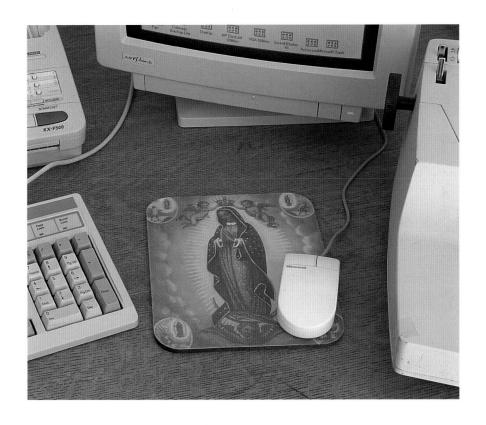

*Previous page: Marion C. Martínez
unites elements of modern technology to
celebrate Guadalupe as an ageless icon.*

*Guadalupe on a mouse pad leads her
followers into cyberspace.*

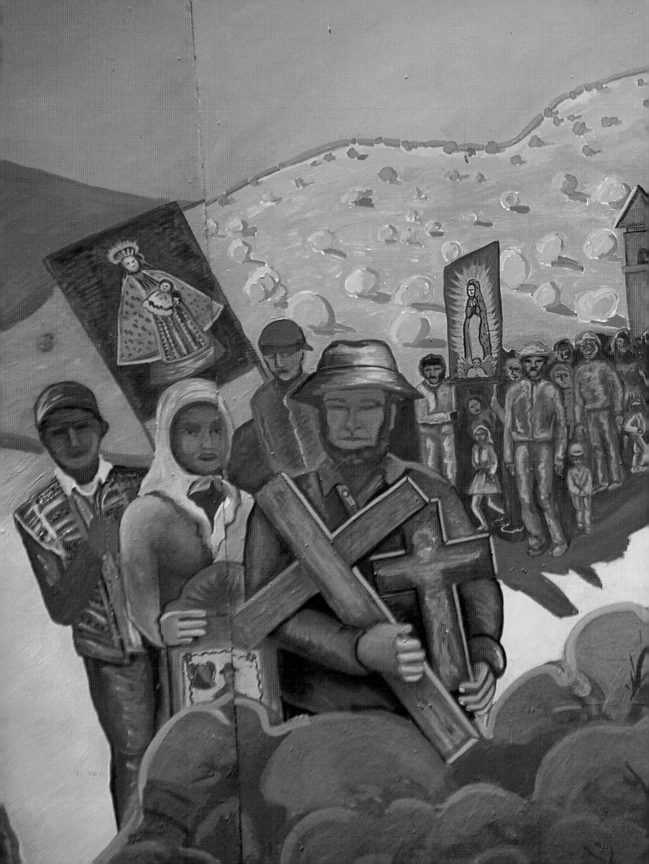

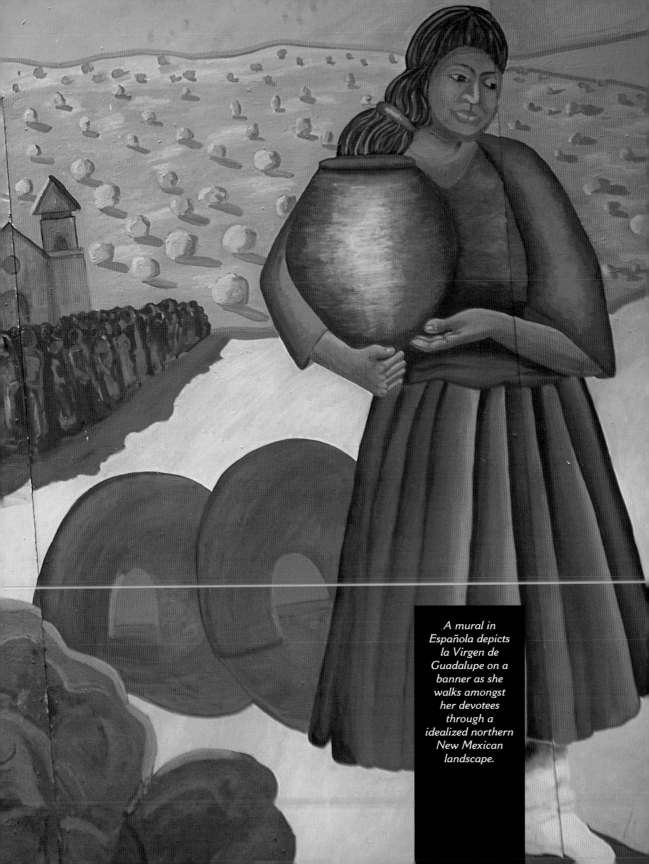

A mural in Española depicts la Virgen de Guadalupe on a banner as she walks amongst her devotees through a idealized northern New Mexican landscape.

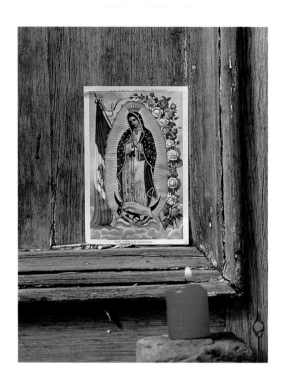

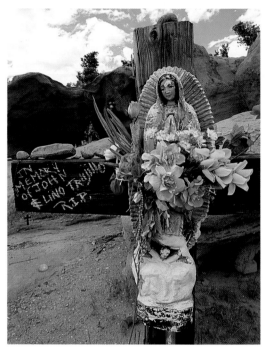

*Guadalupe testifies that
her love persists beyond
this life.*

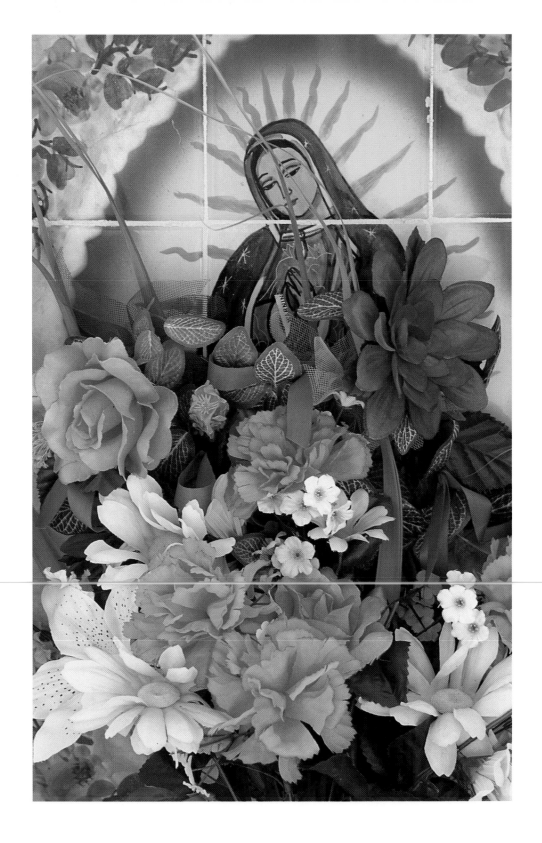

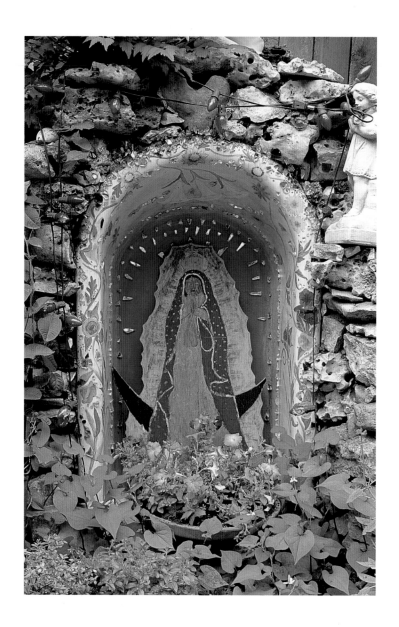

Suggested Reading

Adams, Eleanor B. and Fray Angelico Chávez, eds. and trans. *The Missions of New Mexico, 1776: A Description by Fray Francisco Atanasio Dominguez, with Other Contemporary Documents*. Albuquerque: University of New Mexico Press, 1975.

Anaya, Rudolfo. *Bless Me, Ultima* (illus.). New York: Warner Books, 1994.

Artes de México, edition no. 29. *Visiones de Guadalupe*. Mexico City and Bowers Museum of Cultural Art, Santa Ana, California, 1995.

Await, Barbe and Paul Rhetts. *Charlie Carrillo: Tradition & Soul*. Albuquerque: LPD Press, 1995.

Boyd, E. *Popular Arts of Spanish New Mexico*. Santa Fe: Museum of New Mexico Press, 1974.

Chávez, Fray Angelico. *La Conquistadora*. Santa Fe: Suntone Press, 1983.

Dickey, Roland F. *New Mexico Village Arts*. Albuquerque: University of New Mexico Press, 1990.

Dunnington, J. O. "Three Days is Tortugas." *El Palacio* 95, 2 (Winter-Spring 1996).

Frank, Larry. *New Kingdom of the Saints: Religious Art of New Mexico 1780–1907*. Santa Fe: Red Crane Books, 1992.

Gavin, Robin Farwell. *Traditional Arts of Spanish New Mexico*. Santa Fe: Museum of New Mexico Press, 1994.

Kessel, John L. *The Missions of New Mexico Since 1776*. Albuquerque: University of New Mexico Press, 1980.

Pierce, Donna and Marta Weigle, eds. *Spanish New Mexico: The Spanish Colonial Arts Society Collection*. Santa Fe: Museum of New Mexico Press, 1996. Two Volumes.

Steele, Thomas. J., S.J. *Santos and Saints: The Religious Folk Art of Hispanic New Mexico*, rev. ed. Santa Fe: Ancient City Press, 1994.

Wroth, William. *Christian Images in Hispanic New Mexico*. Colorado Springs: Taylor Museum of Colorado Springs Fine Arts Center, 1982.

The authors wish to extend their heartfelt thanks to all
devotees everywhere whose generous sharing of their love for
Guadalupe is reflected in this *ofrenda* to her spirit.
Viva Guadalupe!

The following photographers and collections have contributed images to
Viva Guadalupe!:

ET	Ed Taylor
GHF	Guadalupe Historical Foundation
JOD	Jacqueline Orsini Dunnington
MOIFA	Museum of International Folk Art, Santa Fe
MMA	Maxwell Museum of Anthropology, University of New Mexico
SCAS	Spanish Colonial Arts Society Colllection, Santa Fe

Project editor: Mary Wachs
Art Director: David Skolkin
Design and production: Susan Surprise
Manufactured in Hong Kong
10 9 8 7 6 5 4 3 2

ISBN: 0–89013–321–2

Museum of New Mexico Press
Post Office Box 2087
Santa Fe, New Mexico 87504